IMAGES
of America

GEORGIA TECH
CAMPUS ARCHITECTURE

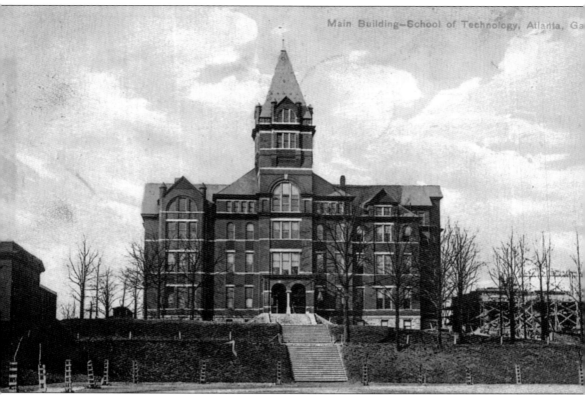

TECH TOWER, 1888. The most iconic building on Georgia Tech's campus remains the first one built: the Administration/Academic building known as Tech Tower. Together with its flanking and originally towered Shops Building (see page 11), the late-Victorian structures announced the establishment of Georgia's technical school with hilltop landmarks that embodied in their uplifting forms the optimism and ambitious aspirations of the new school. Although the Shops Building did not survive, Tech Tower continues to serve as the symbolic emblem of the past and confident future of Georgia Tech. (Courtesy of Georgia Tech Archives.)

ON THE COVER: Brittain Dining Hall (1928) overlooks an open campus green within the east dormitory complex. (Photograph by Robert M. Craig.)

IMAGES
of America

GEORGIA TECH
CAMPUS ARCHITECTURE

Robert M. Craig

ARCADIA
PUBLISHING

Published by Arcadia Publishing
Charleston, South Carolina

Printed in the United States of America

Library of Congress Control Number: 2021931837

For all general information, please contact Arcadia Publishing:
Telephone 843-853-2070
Fax 843-853-0044
E-mail sales@arcadiapublishing.com
For customer service and orders:
Toll-Free 1-888-313-2665

Visit us on the Internet at www.arcadiapublishing.com

To the faculty and alumni of the architecture school at Georgia Tech, past and present, many of whose building designs are illustrated in this volume

CONTENTS

ACKNOWLEDGMENTS

Architectural histories are reliant on photographs (historical and contemporary) of a wide variety of buildings, and for those buildings altered or razed, archival collections are especially invaluable. I am grateful for the assistance of Jody Thompson (archivist), Katie Gentilello (digital projects coordinator), and especially Kirk Henderson (exhibitions program manager) at the Georgia Tech Library and Archives for making available the majority of the images contained in this book. John Holcombe, facilities information systems manager at Georgia Tech's office of capital planning and space management, was also helpful in providing several additional photographs. Most of the other photographs, in particular images of more recent campus architecture, were taken by the author. For additional help with photographs or assistance and clarification with individual "fact checks," I also thank Richard Funderburke, Ron Stang, Megan Kopacko, Randy Zaic, Jack Pyburn, Susan Sanders, and Kristi Campbell. My wife, Carole, continues to aid my writing in various ways, editorial and culinary, and frequently helps with the logistics of fieldwork during photographic site visits, showing infinite patience as I waited for clouds to pass in order to document buildings in "just the right light."

Early research on Georgia Tech's campus architecture was facilitated by release time from teaching during the 2010 summer term.

The majority of images in this volume appear courtesy of the Georgia Tech Archives (GTA) or are photographs by the author (RMC).

INTRODUCTION

Georgia Tech's architectural history extends from the buildings of the late-19th-century Victorian "North Avenue trade school" to the distinctly modern architecture of a major research university. Tech's architecture school has graduated such internationally-renowned designers as John Portman and Michael Arad, the latter the winner of one of the largest architectural competitions in the history of such rivalries, the design of the 9-11 Memorial in New York. Arad's 9-11 Memorial design was executed just a few years after Arad received his master's degree at the architecture school at Georgia Tech. Dispelling the myth that "those who can't do, teach," the early faculty members of the architecture school have historically been doers. For the first 70 years, campus architecture at Tech was mostly designed by the faculty of the architecture school, first Francis Palmer Smith and John Llewellyn Skinner, and then Harold Bush-Brown and Paul Heffernan, each successive heads/directors of the architecture department. From the late 1950s to the present, designs have opened to the wider architectural field, including alumni and sometimes, as in the case of the Catholic Center, designed by a partnership of practitioners who were also active Georgia Tech architecture faculty (Rufus Hughes and Dale Durfee).

Some campus buildings gained national and international acclaim. Heffernan's Modernist architecture was published in national architectural magazines, Terry Sargent's Manufacturing Research Center (MARC) appeared in drawing form in *Progressive Architecture* (*PA*), even before construction, and was subsequently given a *PA* award. When sustainability issues became prominent in the world of architectural design, Georgia Tech president Wayne Clough mandated that campus buildings should be targeted for LEED Gold certification, an opening bid that was advanced to Platinum by his successor president, G.P. "Bud" Peterson; the Clough Undergraduate Learning Commons completed in 2011, the largest building to date on campus, was certified LEED Platinum in 2013.

John Ruskin has observed, "We require from buildings two kinds of goodness: first, the doing their practical duty well; then that they be graceful and pleasing in doing it." Grace and aesthetic pleasure are not expected qualities of the architecture of an engineering school and "institute of technology." Nonetheless, there are moments of wit and Vitruvian delight in Sargent's MARC building, mentioned above. Brittain Dining Hall is nothing short of didactic in its historical references and display of Tech's curriculum represented in sculpture and stained glass, and buildings like the West Architecture Building put on naked display its mechanical and structural systems and disclose to public view unadorned constructional materials. Similarly, Heffernan's original Architecture Building is an object lesson for students in functional zoning. Providing an introduction to Georgia Tech's campus buildings, this book illustrates the varied forms and expressions of architecture "speaking" to visitors on campus, employing the wide dimensions of a visual language to communicate to those with eyes to see.

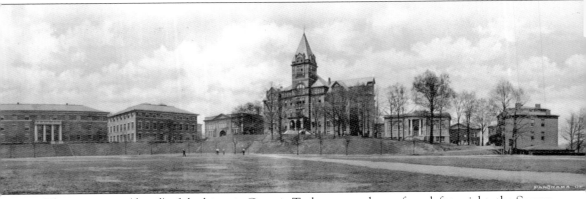

This panorama (detail) of the historic Georgia Tech campus shows, from left to right, the Swann Dormitory, Electrical Engineering (Savant) Building, Old Shop Building, Academic/Administration Building (Tech Tower), Carnegie Library, and Knowles Dormitory. (GTA.)

One

GEORGIA TECH
HISTORIC DISTRICT

The earliest buildings of Georgia Tech, recognized in 1978 as a National Register Historic District, occupied a nine-acre campus on which gradually arose late-Victorian administration and shop buildings, an industrial textile mill structure, a library and a chemistry building both ennobled by classical ornament, a dormitory and an electrical engineering building west of an open green, and a student residential building with small gymnasium (now razed) east of Tech Tower. Indeed, the first (1896) on-campus housing for students (adequately primitive to be nicknamed "the Shacks," now razed) had no running water, electricity, nor a kitchen. Athletics were provided for on an adjacent and uncultivated field called "the Flats," full of ankle-twisting depressions, inhabited by rabbits and snakes, and likely accounting for Georgia Tech's cumulative record before 1901 of winning only two football games since intercollegiate competition began in 1892. The early campus was dominated by the two, originally towered, structures, the 1888 Administration Building (Tech Tower) and the adjacent and contemporary Shop Building; the latter was destroyed by fire in April 1892, immediately rebuilt without its tower in 1892–1893, and finally razed in 1968.

Atlanta architects Bruce and Morgan gave several southern schools a similar start during the same late-Victorian period, erecting brick and often towered administration "main" buildings at Agnes Scott College (1889–1891), Auburn University (then Alabama's Agricultural and Mechanical College, 1889–1890), Clemson University (1891–1892), and Winthrop College (1894–1895), with the latter two in South Carolina. This whole group may derive from Gottfried Norrman's 1882 Stone Hall (later Fountain Hall) at Atlanta University, although Georgia Tech's administration building is more ordered and boasts a more articulated upper tower.

The "historic" Georgia Tech reflected prevailing dichotomies of the times: a "New South" spirit that called for a rigorous encouragement of industry in a region traditionally lacking technological advancement; an engineering school newly planted in a growing metropolis at the heart of the South, an essentially rural region whose cotton economy, for generations, had fed northeastern US and English textile mills, not southern and regional mills; and an institutional architecture of masonry in a city whose prevailing buildings were wood-framed. Moreover, in Atlanta (and throughout the South), architects were mostly imports from other states and countries; no professional architecture degree-granting schools existed in the South before 1907 (Auburn) and 1908 (Georgia Tech and Tulane), although some coursework toward a degree in architectural engineering existed at Tulane in New Orleans as early as 1894.

Founded on October 13, 1885, and named the Georgia School of Technology, the state engineering school completed its administration/academic tower and shop building in 1888, marking the opening of the institution, a school initially granting only a baccalaureate degree in mechanical engineering. Degrees in electrical, civil, textile, and chemical engineering were added by 1901, and the "North Avenue Trade School" was born. The school buildings of Georgia Tech's historic district reflect this early curriculum and established the institution that would become one of the leading engineering and research institutions in the country.

Two of Atlanta's most prominent architectural firms, Bruce and Morgan and Walter T. Downing, produced Georgia Tech's earliest buildings. Bruce and Morgan's experience in building towered county courthouses (Walton, built in 1883, and Newton, 1884) may have influenced their selection to design Georgia Tech's and Agnes Scott College's first academic buildings and Tech's Shop Building. After the college work, the firm would follow with additional county courthouses of like Victorian character (Floyd, 1892; Paulding, 1892; and Monroe, 1896) and further advanced their reputation as designers of prominent public buildings with their design for Concordia Hall (1892–1893) in Atlanta. Their early skyscrapers in the city include the Austell Building (1896–1898, razed), the Prudential/W.D. Grant Building (1898), the Empire Building (1898–1901), and the Fourth National Bank (1904–1905, enlarged and then remodeled) and their turn-of-the-century work also includes churches such as North Avenue Presbyterian (1900) and All Saints Episcopal (1904–1906) as well as neighborhood fire stations (No. 6 in 1894 and No. 7 in 1910). Morgan and Dillon's 1907 Carnegie Building for Georgia Tech served as the school library for 46 years.

Real estate developer Edward Peters, in the 1880s, had provided the land for the engineering school's campus, and just to the east of the site, Peters was already developing a residential district (now "midtown" along Peachtree Street and Piedmont Avenue) where Bruce and Morgan designed several prominent and still extant residences. However, the most prominent late Victorian architect of "artistic homes" was W.T. Downing, Georgia Tech's second significant architect during its formative years and designer of Georgia Tech's Swann Dormitory and the [Savant] Electrical Engineering Building (both, 1901). Downing had established his own firm in 1890 and found his first success in winning the competition for the Fine Arts Building for the Cotton States and International Exposition held in Atlanta in 1895. Downing also excelled in church design, including the Church of the Sacred Heart of Jesus, 1897; Trinity Methodist Episcopal Church, 1911–1912; and First Presbyterian Church, 1915–1919), all three in Atlanta. In 1913, W. T. Downing collaborated with Bruce and Morgan in the design of the Gothic Revival Healey Building, a 14-story tower in the Fairlie Poplar district of Atlanta.

It was Thomas Morgan, the first president of the Atlanta chapter of the American Institute of Architects (1906), who promoted the idea that the Georgia School of Technology should establish an architecture school, a proposal that came to pass in 1908.

Georgia Tech's historic district thus features the work of the city's best architects of the era. They were not native Atlantans, however; Downing was born in Boston, Alexander Campbell "A.C." Bruce was born in Fredericksburg, Virginia, and Thomas Morgan was born in Manlius (Syracuse), New York. In 1909, another out-of-towner, Francis Palmer Smith from Cincinnati, would arrive and change the course of Georgia Tech's and Atlanta's architecture.

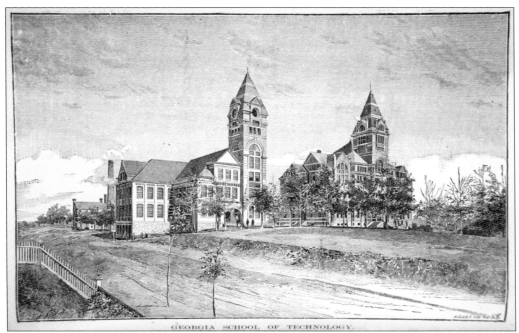

ADMINISTRATION BUILDING AND SHOPS BUILDING. Built in 1888 by architects Bruce and Morgan, Georgia Tech's "main" academic/administration building, with its complementary wood and machine "shops building," reflected the philosophy of Tech's educational system in the early years—equality between the shop and academic curricula. The students and faculty worked under a contract system, competing with local contractors and providing an important source of revenue for the school. (GTA.)

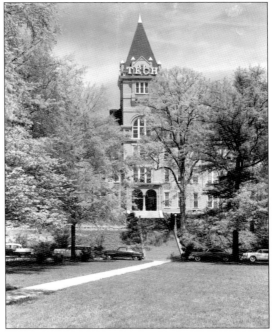

ACADEMIC BUILDING "TECH TOWER," 1888. Tech Tower featured the kind of late-Victorian masonry architecture familiar in Southern courthouses and collegiate "mains" of the period, many designed by Bruce and Morgan. Red brick with decorative corbels, terra-cotta insets, limestone lintels and bands, and contrasting white window trim set the precedent for redbrick masonry buildings, which continued to characterize Georgia Tech's campus architecture for decades to follow, albeit in varying styles. (GTA.)

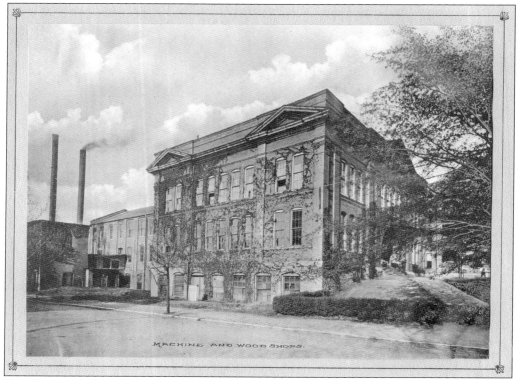

THE (REBUILT) OLD SHOPS BUILDING, 1892. The 1888 shops building was destroyed by fire in 1892 and immediately rebuilt without its tower. The façade was a balanced composition with central pediment over a projecting central bay; the strong and deep arched entry recalled 1880s work by Henry Hobson Richardson while the classical character looks forward to the Lyman Hall Chemistry Building that would be erected 14 years later (1906). (GTA.)

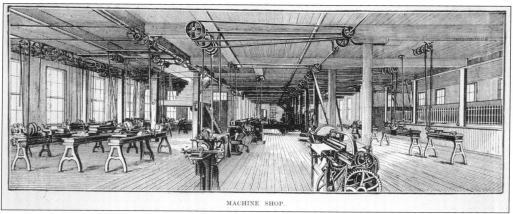

SHOPS BUILDING INTERIOR. With similar interior features, including a foundry and machine shop, with a woodshop wing behind, the rebuilt shops building continued contract production, including iron columns for Grant Theater and gates for Oakland Cemetery. After disputes arose with local labor unions, the contract system was abandoned. The rebuilt shops were finally demolished in 1968, its site marked today by the Corliss Pump (steam engine) and Harrison Square. (GTA.)

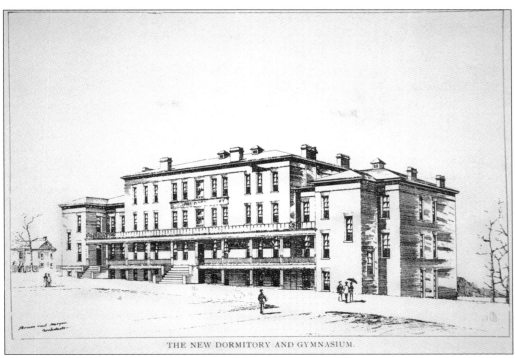

THE NEW DORMITORY AND GYMNASIUM.

KNOWLES DORMITORY, 1897 (RAZED). The first student housing utilized temporary frame "shacks" retained for a short period on the land donated for the school. In 1897, a more-permanent brick building, Knowles Dormitory, was erected, including a dining facility and gymnasium, the latter little more than an exercise room. Jimmy Carter's later residency in Knowles was not enough historical significance to preserve the building, which was demolished in 1992. (GTA.)

SWANN DORMITORY, 1901. Across the campus green is Tech's second dormitory, designed by W. T. Downing and donated by school patron James Swann in memory of his wife, Janie Austell Swann. Renovated twice since, in 1964 and 2006, today, the Swann Building houses the Modern Languages Department. (GTA.)

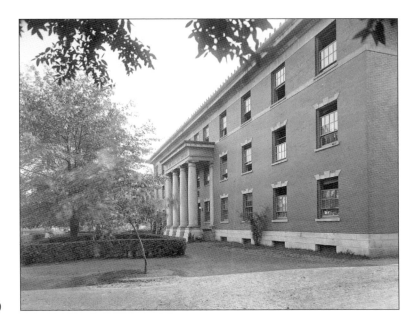

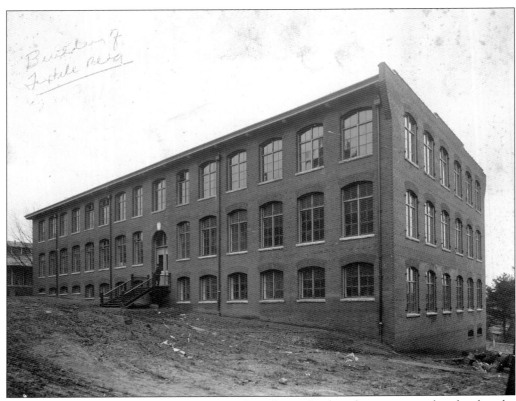

AARON FRENCH TEXTILE BUILDING, 1898. Significant funding for a new textile school and a building to house it was secured from Pittsburgh businessman Aaron French who responded to the Georgia legislature's requirement of additional funds to match the legislative appropriation for a new textile school. The French Textile Building that resulted was the school's most utilitarian structure to date, a plain building of industrial character that might well have been erected among the plain style masonry textile mills of New England. A full array of manufacturing and processing equipment filled the factory teaching rooms and shops within, with rooms for spinning, spooling, and cone winding, for weaving, and for dyeing fabric; a cloth room with brushes, folders, and nappers, and practice rooms containing handlooms, power looms, and other textile manufacturing equipment. (GTA.)

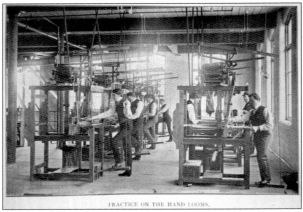

PRACTICE ON THE HAND LOOMS.

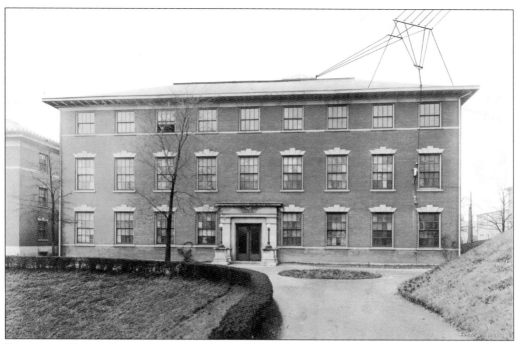

ELECTRICAL ENGINEERING (SAVANT) BUILDING, 1901. Named for an electrical engineering professor, the first EE building was a companion to Swann dormitory, also designed by Downing. Together they frame the west edge of the campus green, each articulated minimally by regular fenestration capped by lintel and keystone, while Downing gives Swann a more monumental tetrastyle Roman Doric portico on its eastern front. (GTA.)

PRESIDENT'S HOUSE, 1903. Turn-of-the-century houses survived for many years along North Avenue opposite the new engineering school. Many were used temporarily by fraternities, while one from 1903 served as the school's president's house until 1948. Marion Brittain, Georgia Tech's fourth president (1922–1944), had served as state school superintendent from 1910–1922 and lived in a Neoclassical house he built in 1911 at 1109 West Peachtree Street (razed in 2017). (GTA.)

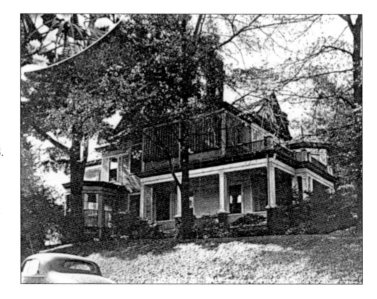

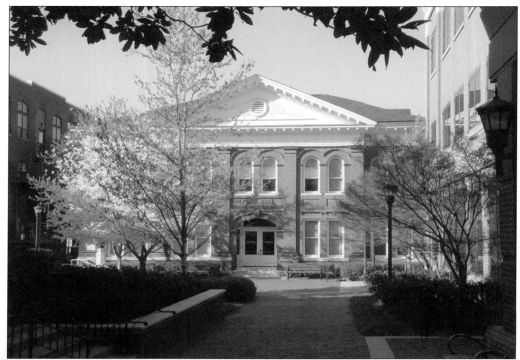

LYMAN HALL CHEMISTRY BUILDING, 1906. Capt. Lyman Hall, a graduate of West Point, was hired in 1888 as Georgia Tech's first mathematics professor. With an engineering background, he introduced surveying and engineering applications into his mathematics coursework at Georgia Tech. In 1896, Hall became the school's second president. At the time, the school granted only a mechanical engineering degree. Seeking to expand the school, Hall introduced new degrees in electrical engineering and civil engineering in 1896, textile engineering in 1899, and engineering chemistry in 1901. It is thought that his early death in 1905 at age 46 was the result of stress raising money for a new chemistry building—a building, when completed in 1906, that was named for him. (Above, RMC; below GTA.)

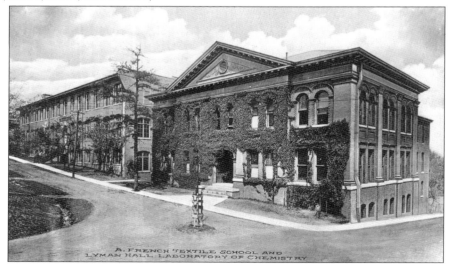

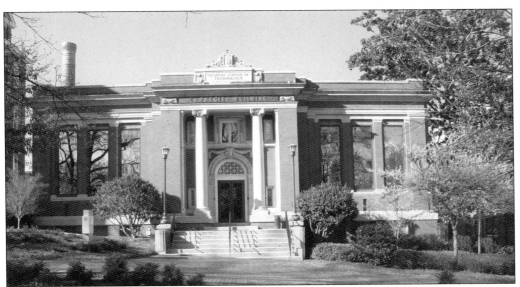

CARNEGIE LIBRARY (CARNEGIE BUILDING), 1906–1907. Georgia Tech's library of 2,500 volumes was crowded into limited space on the second floor of the administration building when Kenneth Matheson was appointed president of the institution. He identified a new library building as an immediate priority and contacted Andrew Carnegie, who was typically giving $20,000 to communities around the country for the construction of "Carnegie libraries," to be matched by 10 percent for book purchase, trained staff, and building maintenance. Morgan and Dillon, Atlanta's premier architectural firm of the day, provided this Beaux-Arts classical library structure with its striking decorative entry. After Paul Heffernan's Price Gilbert Library opened in 1953, the Carnegie Building was converted to administrative offices for the university president. (RMC.)

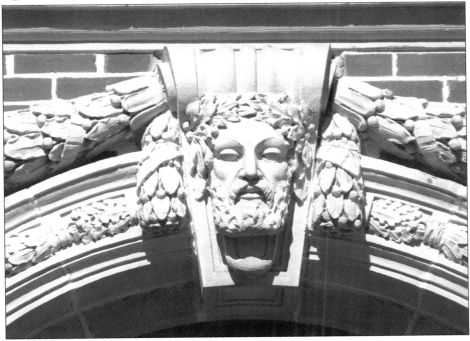

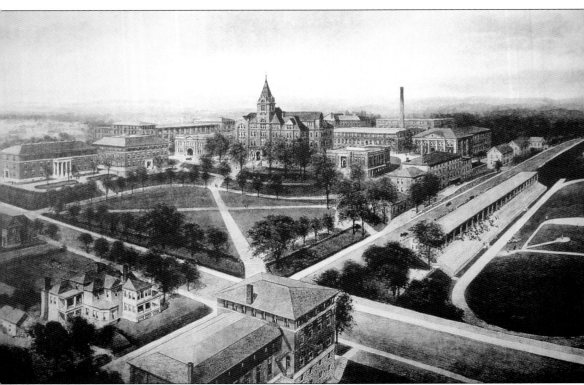

GEORGIA TECH CAMPUS, C. 1910–1912. When Francis Palmer Smith came to Georgia Tech in 1909 to serve as head of the new Department of Architecture, the North Avenue engineering school was just over two decades old. This bird's-eye view of about 1912 shows the campus as it had developed by that date, namely the dozen buildings identified in the National Register Historic District, including Francis Smith's c. 1910–1912 campus designs. (GTA)

Two

ARCHITECTURE UNDER FRANCIS PALMER SMITH AND JOHN LLEWELLYN SKINNER, 1909–1925

When Ed Ivey and fellow students petitioned the school's administration to initiate a program of architectural studies, a discipline authorized in the initial charter to be part of the engineering school's curriculum but not yet inaugurated, Prescott A. Hopkins from Boston was named head of the new architectural department in 1908. Hopkins, however, resigned after one year, and Georgia Tech found itself with a new architecture department and a handful of enrolled students but without a director.

Warren P. Laird of the University of Pennsylvania recommended his former student Francis Palmer Smith for the job. Having failed to entice Smith to join his own faculty at Penn, Laird encouraged Georgia Tech to appoint the 23-year-old Smith as professor and "head of architecture" at Georgia Tech. Smith sought to emphasize design over technology and engineering, and Georgia Tech agreed. Smith imported to Tech the Beaux-Arts curriculum from the University of Pennsylvania, a course of study long established in Paris at the École des Beaux-Arts, and thus, Georgia Tech's architecture school began its long tradition of architectural studies emphasizing excellence in design. The new architecture department would become a College of Architecture in 1978 and has recently been renamed the College of Design.

Smith's impact on the architecture school and the architecture of Atlanta and the South would be profound. Among Smith's first students were Philip Shutze, whom Henry Hope Reed of New York later called "America's greatest living classical architect." Smith also trained Ed Ivey, Buck Crook, Flip Burge, Preston Stevens, and others whose partnerships (Ivey and Crook, Burge and Stevens, Hentz Adler and Shutze) would constitute what was later dubbed the Southern School of Classicism. In 1922, Smith would form his own partnership with architect Robert Pringle (Pringle and Smith), and these several firms (and others Smith trained) literally built Atlanta during the 1910s and 1920s.

While serving as head of architecture at Georgia Tech, Smith designed the school's infirmary, its power plant, and a new mechanical engineering building. In so doing, Smith established the long-standing tradition of Georgia Tech's campus architecture being designed by the school's architecture faculty, a practice that would continue for half a century. Moreover, Smith's 1921 "preliminary plan for the architectural development of the Georgia School of Technology" was the first master plan for the campus, on which Smith collaborated with his former University of Pennsylvania teachers, Warren P. Laird and Beaux-Arts-trained Paul Cret. Under Francis Palmer

Smith, Georgia Tech's architecture school became firmly established in the Beaux-Arts tradition and the school's campus architecture by Smith, and indeed, for almost 30 years after his first campus building in 1910, continued to reflect traditional collegiate styles unchallenged until the modern work of Paul Heffernan in the late 1930s and 1940s.

Smith met Robert Pringle when they were both assisting W.T. Downing as draftsmen, and Smith's decision to open a more active practice with Pringle ended his term as head of the department in June 1922. The tenure of his successor, John Llewellyn Skinner, was brief, with Skinner also serving as both teacher and designer of campus buildings. In 1925, Skinner decided to open a practice in Florida, and in 1927, he initiated the first program in architecture at the University of Miami, an architecture school that later became famous as a seedbed for the New Urbanism under Elizabeth Plater-Zyberk and Andrés Duany.

As significant, Skinner hired the talented Harold Bush-Brown (his friend when they were both at Harvard) to join the Georgia Tech faculty in the fall of 1922, and three years later, Bush-Brown succeeded Skinner as department head. Harvard, during their student days, was a Beaux-Arts school, and both Skinner and Bush-Brown continued the practice of Georgia Tech's architecture faculty designing traditionally-styled campus buildings.

Under Skinner's brief tenure, three campus buildings were erected: the Ceramics Engineering Building (1924), the Neo-Jacobean Brown Dormitory (1925), and the expansion of the campus stadium stands in 1924 (the first significant construction on what was later named the Bobby Dodd Stadium). Skinner also designed a fraternity house for Beta Theta Pi in 1925–1926 (now razed). Perhaps the most significant was Brown Dorm, whose traditional, brick, neo-medieval forms initiated a restrained Jacobean style for East campus dormitories. The precedent and real catalyst of the style was Robert and Company's Physics Building of 1922–1923, for which Francis Smith had served as associate architect and one of Smith's last projects for the campus.

Throughout Skinner's years as head of architecture as well as the early years of Bush-Brown's lengthy period of leadership of the department, the architecture program's curriculum continued to maintain the same Beaux-Arts character initiated by Francis Smith. The highly competitive Georgia Tech architecture program was consistently recognized in nationwide design competitions and, in 1925, was elected to the Association of Collegiate Schools of Architecture. Admitted because of its "well balanced curriculum and thorough professional course and high order of student attainment," Tech was the only southern member. In 1924, Tech's architectural school was ranked first in the South and fifth in the nation.

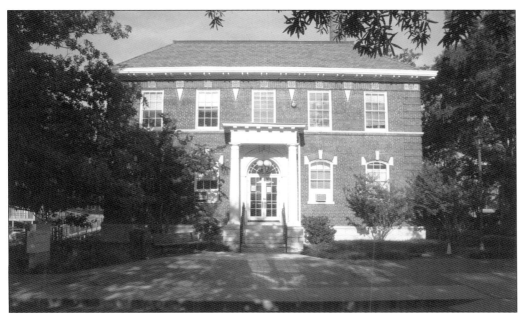

WHITEHEAD INFIRMARY (CHAPIN BUILDING), 1910–1911. With a professional architecture school established in 1908, Georgia Tech began a practice that would continue for almost half a century: utilizing the architecture faculty as designers of campus buildings. The new head of architecture, Francis Palmer Smith, designed his first Georgia Tech building in 1910, the school's infirmary. Although the Lyman Hall Chemistry Building of 1906 may have provided a more-monumental classical façade in the Beaux-Arts tradition, the balance and proportions of Smith's simple hipped-roofed block of textured tapestry brick and decorative insets evidenced the judicious eye of a classically trained architect in that tradition. The arched entry and simple fluted-columned porch are almost domestic in scale, offering students an appropriate sign of calm and welcome, as a campus infirmary should convey. (RMC.)

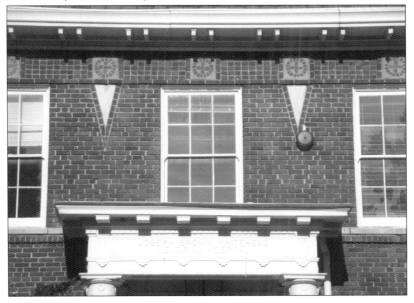

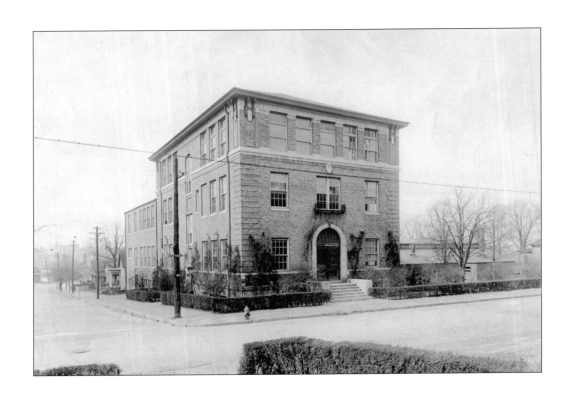

NEW SHOP (COON) BUILDING, 1910–1912, 1920. The new mechanical engineering shop building was designed in five units, with shop wings to house lengthy belt shafting rooms between two projected classroom blocks. The north classroom block, as shown below, was never built, although the three-story south block was erected between 1910 and 1912, with a west storage wing behind and blacksmith/foundry extending north of that. The main south block contained offices and a library on the first floor, classrooms on the second floor, and a drafting room on the third floor. Then, completed in 1920, a two-story, eleven-bay shop wing housed a wood shop above the machine shop with a smith shop and foundry behind, with the front and rear wings separated by lengthy courtyards providing natural lighting. (GTA.)

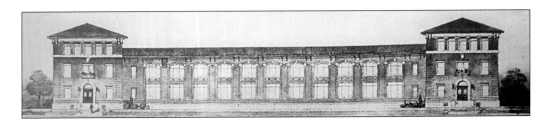

ROCKEFELLER YMCA (ALUMNI FACULTY HOUSE), 1909–1912. Soon after Francis Smith's arrival on campus, the successor firm (Morgan and Dillon) of Georgia Tech's first architects (Bruce and Morgan) completed plans for a campus YMCA. John D. Rockefeller then offered $50,000 to build the structure if the school could match half that amount in private funds. The "Y" opened in 1912. (RMC.)

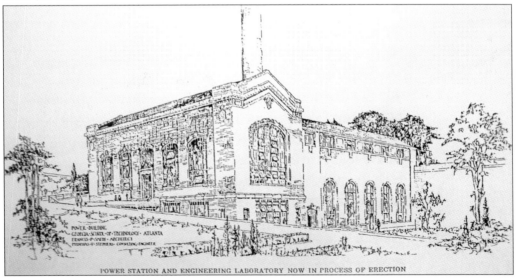

CENTRAL HEATING/COOLING PLANT, 1915–1918. The robust forms of the power plant are suitable to its purpose and are further landmarked by the 210-foot-high smokestack. Ornamental panels reference power, steam, electricity, and light, inscribed with the names of Edison and others associated with their development. Smith's design was adapted from a preliminary sketch by Phinehas V. Stephens. (GTA.)

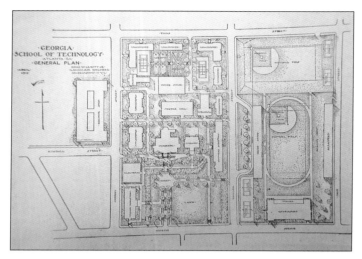

GENERAL CAMPUS PLAN, 1912. New York landscape architect Charles W. Leavitt Jr. recorded the layout of existing campus buildings in 1912, including the planned 1913 power plant, as well as "unassigned" buildings, which he drew as schematics in an orderly layout of campus buildings. Nine years later, Francis Smith collaborated with his former University of Pennsylvania teachers to produce a major campus master plan. (GTA.)

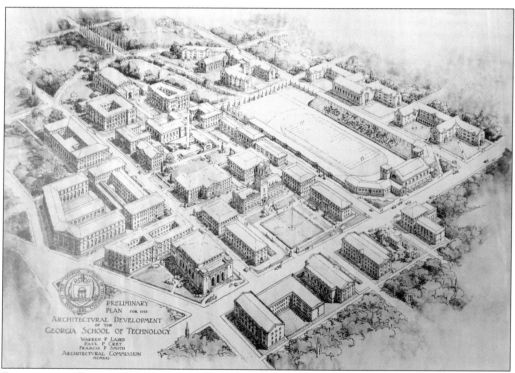

PRELIMINARY CAMPUS DEVELOPMENT PLAN, 1921. Designed by Warren P. Laird, Paul P. Cret, and Francis Palmer Smith, the 1921 perspective records and incorporates then-existing campus structures as well as reimagines and projects future buildings, the whole generalized as an ordered campus of compact buildings aligned along existing east/west and north/south roads and conceived as regularized three-to-four-story rectangular academic blocks. (GTA.)

PHYSICS (DAVID M. SMITH) BUILDING, 1922–1923. The Physics Building introduced to Georgia Tech's campus architecture what became a characteristic Neo-Jacobean style of simplified collegiate brick medieval forms. The imagery would continue to inform the design of classroom buildings and especially campus dormitories for 25 years. Gables, double-height oriel windows, and a classical entry inform the Physics Building prototype. (GTA.)

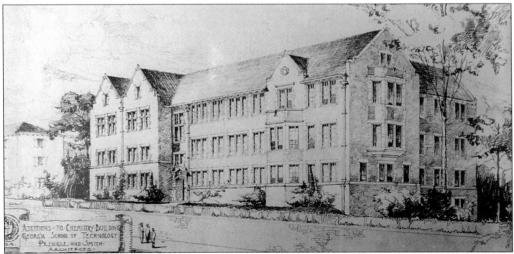

WILLIAM H. EMERSON BUILDING, 1925. Francis Smith returned to campus three years after his retirement from the faculty to erect this extension to the chemistry building. It continued the neo-medieval aesthetic inaugurated at the Physics Building, as did his several unexecuted designs for the developing campus, including projects for a quadrangle at the Emerson Building (1926) and for a gymnasium (1923). (GTA.)

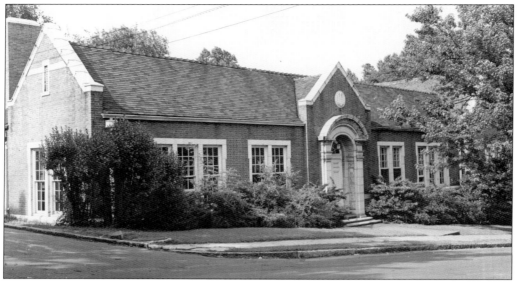

CERAMICS (STEPHEN HALL) BUILDING, 1924. The School of Ceramics was established in 1924 in a building designed by "the Georgia Tech Architecture Faculty" that later served as the Naval ROTC Armory. John Llewellyn Skinner was the new head of the architecture school, serving a brief tenure until 1925. Faculty members practicing as Bush-Brown and Gailey designed an addition in 1939, a WPA project. (GTA.)

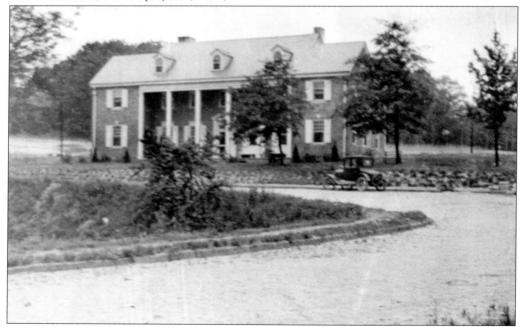

BETA THETA PI FRATERNITY, 1925–1926 (RAZED). The original Beta house was both Southern and colonial in character, with a dominant colossal portico recalling Mount Vernon but called "L'il Tara," presumably to be more "Greek" in its reference to *Gone With the Wind* Greek Revival imagery. A new house (1994–1995), inspired by the old, was designed by fraternity chapter alum Randy Zaic. (GTA.)

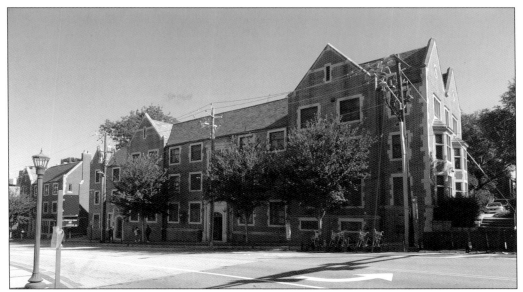

BROWN MEMORIAL HALL (DORMITORY), 1925. Brown is the oldest and smallest residence hall on the east campus. Continuing the Neo-Jacobean style of the Physics Building, architects Stowell, Bush-Brown, and Skinner applied the aesthetic to Brown Hall. After the departure of Skinner and Stowell in 1926, Harold Bush-Brown's east campus development continued the traditional and picturesque neo-medieval aesthetic, with additional Bush-Brown dormitories surrounding his masterwork, Brittain Dining Hall. (RMC.)

O'KEEFE JUNIOR HIGH SCHOOL, 1924. Acquired by Georgia Tech in 1979, O'Keefe was one of a 1920s series of (often Romanesque Revival) Atlanta public schools whose independent designs (this one by Marye Alger and Alger) were supervised and, to a degree, standardized by A. Ten Eyck Brown. West campus's Couch Building, a public elementary school built in 1929 by G. Lloyd Preacher, was acquired by Georgia Tech in 1974. (RMC.)

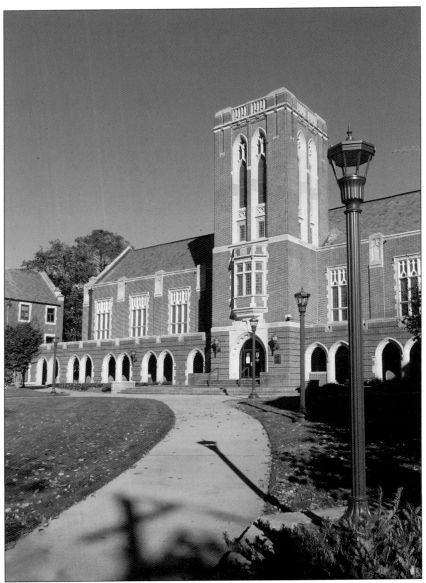

BRITTAIN DINING HALL, 1928. Bush-Brown and Gailey's masterwork, Brittain Hall, was, in many ways, a collaboration of several of Georgia Tech's departments: the architecture department designed the building, the ceramics department manufactured the tile for the floor of the tower, the mechanical engineering department supplied the wrought iron for the light fixtures in the main hall, and the textile department made tapestries and curtains for the president's dining room. Julian Hoke Harris, an architecture student in the class of 1928, designed the stained glass in the south window and returned, after studying at the Pennsylvania Academy of Fine Arts in Philadelphia, to begin his career as a sculptor, carving the 10 carved limestone heads that adorn the arcades flanking the tower and that depict historical figures representing subjects taught at Georgia Tech. The building's setback siting, forecourt, and flanking dormitories recall a traditional university quadrangle. Considered Bush-Brown's finest building on campus before Heffernan, the neo-medieval dining hall retains its original function today. (RMC.)

Three

TRADITIONAL ARCHITECTURE UNDER HAROLD BUSH-BROWN, 1925–1939

Harold Bush-Brown remained head of architecture at Georgia Tech for longer (1925–1956) than any director or dean in the history of the school. As an educator and practitioner, he stewarded the transition from the classical tradition of design education (based on the premise that architecture is a fine art and beauty is its objective) to the "Bauhaus" philosophy of total environmental design (based on modern technology, an abstract aesthetic, and functionalism). Brittain Dining Hall (built in 1928 by Bush-Brown and Gailey) is a campus landmark in the first tradition, and Paul Heffernan's Architecture Building (1952 by Bush-Brown, Gailey, and Heffernan) is an example of the second. Bush-Brown documents this architectural "revolution" in his 1976 book, published by the Whitney Library of Design in New York, *From Beaux-Arts to Bauhaus and Beyond.*

Student projects from the earliest classes taught by Francis Smith (1909–1922) well into the administration of Bush-Brown produced elaborately rendered drawings comparable to *grand-prix* competition drawings at the Ecole des Beaux-Arts in Paris, and many won awards and "mentions" in regional and national competitions in the United States sponsored by the Southeastern Intercollegiate Architectural Competition and the Beaux-Arts Institute of Design in New York. On the occasion of the 2008 centennial of the architecture school, Elizabeth Dowling and Lisa M. Thomason published *One Hundred Years of Architectural Education: 1908–2009, Georgia Tech* (published by the Georgia Tech College of Architecture in Atlanta in 2009), a volume filled with student drawings over the course of the history of the school. Four years later, a monograph appeared authored by the current writer and entitled *The Architecture of Francis Palmer Smith: Atlanta's Scholar-Architect* (published by the University of Georgia Press in 2012), and its early pages (1–15) discussed and illustrated Smith's student projects at the University of Pennsylvania, as well as those of his fellow students there and representative designs of Georgia Tech students that he taught in the Beaux-Arts tradition. These books document how students were educated at Beaux-Arts schools by faculty practitioners who looked to history for inspiration and who considered architecture an art.

Bush-Brown's campus architecture was historicist during these years, organizing east campus dormitories around his monumental and focal dining hall and enriching classroom buildings such as his Guggenheim Building with ornament, inscriptions, and classical accents. Bush-Brown directed the school's academic work as well as the campus's architectural design throughout both the optimistic 1920s as well as the Depression years of the 1930s. Following the economic crash,

recovery programs under Roosevelt's New Deal substantially contributed to campus architecture, especially through the Public Works Administration (PWA) and the Works Progress Administration (WPA). The PWA supported the building of the Civil Engineering Building and the Mechanical Engineering Drawing Building, the Howell and Harris Dormitories, the Daniels Chemical Building addition, and the Engineering Experiment Station Building. The WPA financed the Auditorium/Gymnasium Building, the Athletic Association Building, the Chemical Engineering Building, and the addition to the Lyman Hall Chemistry Building. Under the Civil Works Administration, the Armory and Techwood Dormitory (McDaniel) were constructed.

When Paul Heffernan arrived at Georgia Tech in 1938 following his graduate work at Harvard and two years at the Ecole des Beaux-Arts in Paris, he became the principal designer for the subsequent campus projects that Bush-Brown's "architectural department" would continue to design. Heffernan brought additional prestige to the department. Like Skinner and Bush-Brown, Heffernan had a master's degree in architecture from Harvard, but he had also won the Paris Prize.

The Lloyd Warren Fellowship (or Paris Prize) is a national architectural competition established in 1904 and sponsored by the Society of Beaux-Arts Architects whose Beaux-Arts Institute of Design in New York (founded 1916) administered the prize. Each year, a jury of leading architects selected one student based on his or her design solution and renderings of an assigned architectural "problem" or commission. The winning student traveled to France and was admitted for two years of study at the Ecole des Beaux-Arts in Paris, bypassing the normal and rigorous entrance examinations. Paul Heffernan won the 28th Lloyd Warren Paris Prize in 1935 (for "A Model Dairy," the assignment that year), and after his study at the Beaux-Arts, Heffernan returned to the United States in 1938 and joined Bush-Brown's architecture faculty at Georgia Tech as well as Bush-Brown and Gailey's architectural practice. Heffernan would almost immediately execute modern work on campus.

Bush-Brown's pre-Heffernan work on campus, however, followed, for the most part, the Jacobean aesthetic initiated by Robert and Company's Physics Building of 1922, designed with Francis Smith as associate architect. The Physics Building was sited at the north end of the (then developed) campus, at the corner of Cherry Street and Third Street (now Bobby Dodd Way). A new Modern Classic aesthetic would emerge in the 1930s in buildings on Third Street (a transition from traditional to modern), and Heffernan's new functionalist architecture of the 1940s and 1950s would form a modern academic village in an emerging north campus district. But the Neo-Jacobean Physics Building became the model for the east campus dormitories that Harold Bush-Brown and Herbert Gailey would construct along Techwood Drive and Williams Street between North Avenue and Third Street. Here is collected Bush-Brown's traditional redbrick architecture for Georgia Tech, still Beaux-Arts and "collegiate" in spirit. The ensemble on Techwood Drive includes Skinner's Brown Dorm but is otherwise exclusively Bush-Brown and Gailey work: Brittain Dining Hall (built in 1928), Harris Dormitory (1926), Cloudman Dormitory (1931), and east of them on Williams Street, Howell and Harrison Residence Halls (1938–1939). Ultimately, in 1947, Bush-Brown, Gailey, and Heffernan would add the picturesque Smith Dormitory and the Towers/Glenn Dormitory quadrangle. During the same period, the campus practice of Bush-Brown and Gailey designed classroom and laboratory buildings, including the Guggenheim Aeronautics Building (1930–1931) and the Mechanical Engineering Drawing Building (1938–1939).

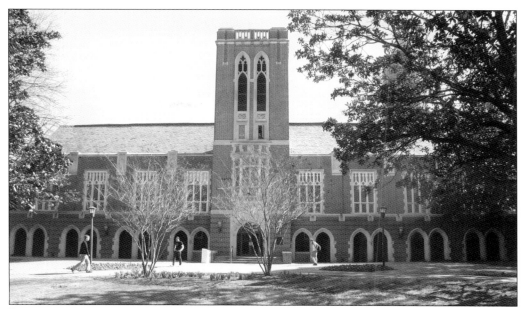

BRITTAIN DINING HALL, WEST ELEVATION. Brittain Dining Hall, widely viewed as the best building on campus by Bush-Brown and Gailey, is an exemplary work of didactic architecture, incorporating in both its arcade sculpture outside and its stained glass inside, representations of the curriculum subjects taught at the engineering school. The building is even ornamented by carved yellow jackets, the nick-namesake of the school's athletic teams. (RMC.)

CORBEL HEADS, JULIAN HARRIS, 1933. Harris's 10 limestone heads represent historical figures associated with subjects taught at Georgia Tech, with three in art: Michelangelo (fine arts), Eli Whitney (textiles), and Della Robbia (ceramics); four in science: Lavoisier (chemistry), Darwin (geology), Aristotle (biological sciences), and Archimedes (physics); and three in engineering/ mathematics: Leonardo da Vinci (civil, mechanical, and aeronautical engineering), Thomas Edison (electrical engineering), and Isaac Newton (mathematics and astronomy). (RMC.)

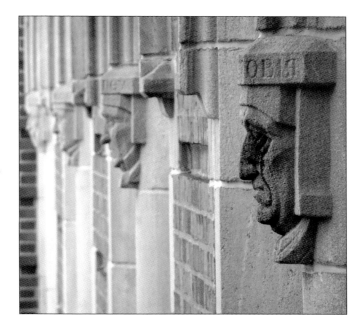

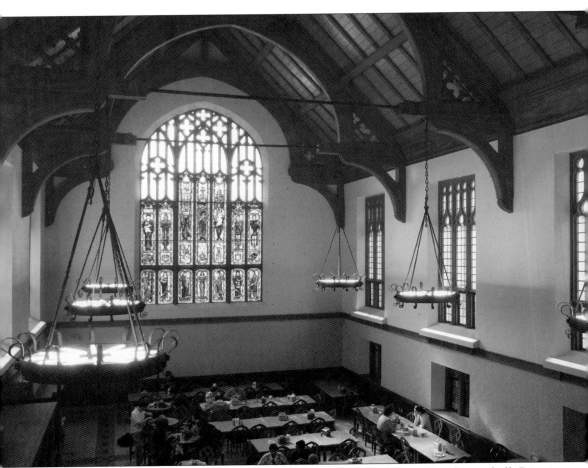

INTERIOR BRITTAIN DINING HALL. In the tradition of the English medieval great hall, Brittain Dining Hall features a community room ennobled by an open truss, lighted by large Gothic Revival windows, and entered from a screen's passage. In Collegiate Gothic architecture, the space recalls English university common rooms, which lent an air of formality to college dining with dons and students often continuing tutorials over meals. Harold Bush-Brown may well have had such university commons in mind when he designed Brittain Dining Hall, including Memorial Hall at Harvard (his alma mater), built in 1870–1878 in this tradition by Ware and Van Brunt. The clear glass in east and west windows brings light into the vast interior, but what dominates is Julian Harris's south window, a colorful and traditional figural window full of symbolic figures referencing subjects taught at Georgia Tech, much as his carved corbel heads of Darwin, Leonardo da Vinci, Archimedes, and others do on the building's outside arcade. (RMC.)

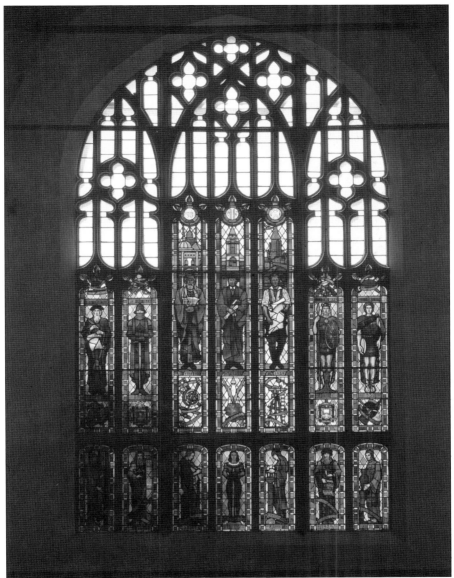

SOUTH WINDOW, BRITAIN DINING HALL. The great window features stained glass by Julian H. Harris, designed in 1924 when Harris was a student in the architectural program, and executed by Lamb Stained Glass Studio, New York, the whole completed by 1932. Student class gifts from graduating classes of the late 1920s provided funds for this project. The figures, buildings, and objects depicted in the glass represent science and engineering subjects comprising the school's curriculum, as well as references to athletics and the military programs of the school. The north window opposite remains clear, awaiting, perhaps, another student design, although it might well be filled with grisaille glass, as north windows in medieval times often were, in order to admit more light into the space from north-facing windows. Julian Harris abandoned the active practice of architecture as soon as he graduated, pursuing sculpture instead, and many of his sculptural works are extant on campus, including dedicatory building plaques and commemorative reliefs, busts of Georgia Tech leaders, and architectural ornament, but no other stained glass. (RMC.)

NATHANIEL EDWIN HARRIS DORMITORY, 1926. Harris Dorm extends north of Brown Hall to frame Brittain Dining Hall and anticipates Bush-Brown's placement, opposite, of Cloudman Dormitory. Today, Harris is one of two suite-style Tech dormitories (the other is Woodruff Dorm on the west campus) in which two double rooms are joined by a shared bath in a four-person suite. (RMC.)

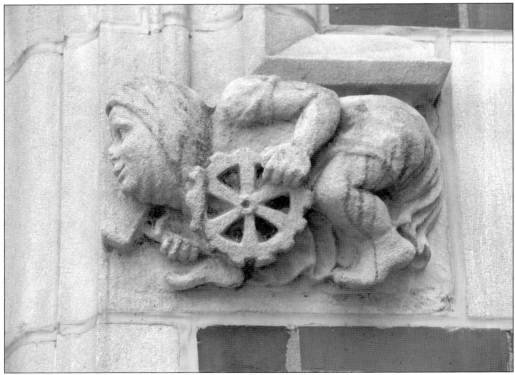

DECORATIVE SCULPTURE, HARRIS DORM. Aware of the role of decorative sculpture on medieval buildings, both figurative (portal jambs), narrative (capitals), symbolic (tympanums), and whimsical (bosses and misericords), architect Bush-Brown frequently ornamented his neo-medieval collegiate buildings at Georgia Tech with sculptural figures and natural plant carvings, the latter best represented at Cloudman Dormitory's entry overdoor panel. There is no record of the sculptor who executed the imaginative Harris dorm figures (RMC.)

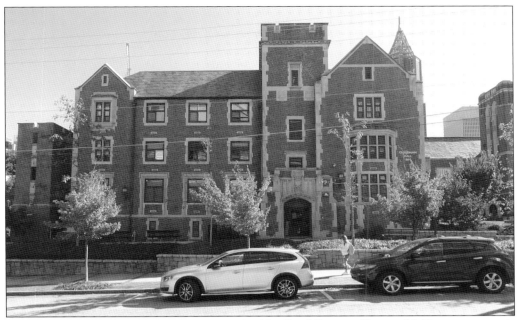

Josiah Dana Cloudman Dormitory, 1931. North of Brittain Dining Hall's open green is Cloudman Dormitory, a brick with limestone trim building that, like Harris and Brown dorms, lines Techwood Drive while contributing to a multi-building composition, several years in the making. Brittain Hall dominates, but Cloudman reflects the school's continuing development of an "east campus" of traditionally styled collegiate residence halls. (RMC.)

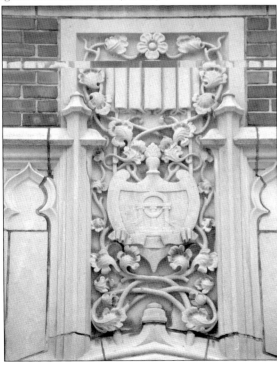

Carved Decorative Sculpture, Cloudman Dormitory. Cloudman dormitory was intended for co-op students—hence the carving of "Labor" and "Study" on the tower. A frontispiece features carved foliate forms. Bush-Brown's intricate drawings for these panels survive and demonstrate his keen interest in decorative arts as a necessary ornament to the mother of the arts, architecture. (RMC.)

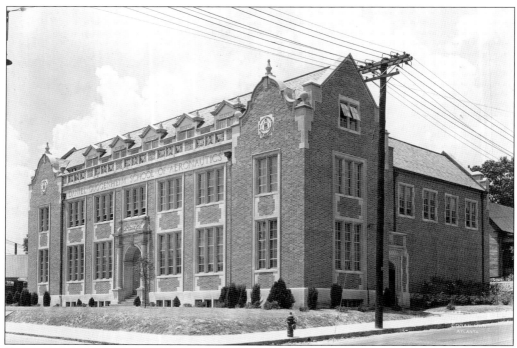

GUGGENHEIM AERONAUTICS BUILDING, 1930–1931. This building was constructed utilizing $300,000 from a Guggenheim grant of 1930. Georgia Tech was one of only six colleges in the United States qualified for the grant to establish a school of aeronautics. The generous amount is reflected in the building's elaborately ornamented North Avenue façade, an elevation enriched by pedimented gables with finials, a parapet pierced by decorative panels of eagles flanked by winged Pegasus figures, and a large limestone band inscribed with "Daniel Guggenheim School of Aeronautics." End bays are capped by Dutch gables with curved and counter-curved edges trimmed in limestone and with a finial (and side urns) rather than a pedimented gable top. Textured brickwork and windows trimmed in stone further enrich the building. (Above, GTA; below, RMC.)

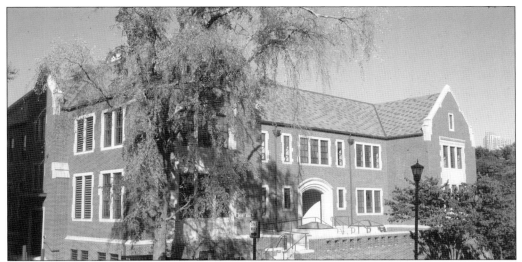

CIVIL ENGINEERING (OLD CE) BUILDING, 1938–1939. This was the last Collegiate Gothic campus design prior to the 1938 arrival of Paul Heffernan. It projected basement and two-story laboratory spaces for both hydraulic labs/water resource research and highway labs (likely never installed); by the 1950s, space originally to be dedicated for both was being utilized for hydraulics research. (RMC.)

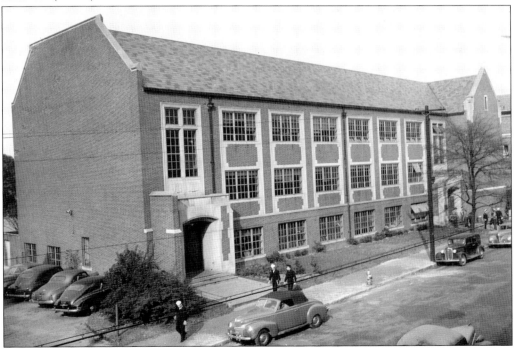

MECHANICAL ENGINEERING (ESM) DRAWING BUILDING, 1938–1939. Built as the Engineering Drawing and Mechanics Building and funded by the FWA (Federal Works Agency, Public Works Administration), this transitional building, with its neo-medieval entry porches, adapts large industrial windows stacked in a relatively open three-story elevation to edge forward toward a less-traditional aesthetic. (GTA.)

DANIEL LABORATORY (CHEMICAL ENGINEERING), 1941–1942. Designed by Herbert Gailey, the building retains Georgia Tech red tapestry brick with limestone trim and the familiar neo-medieval entry porch, while the late-Deco decorative panel over the entry discloses the building's 1940s date. (GTA.)

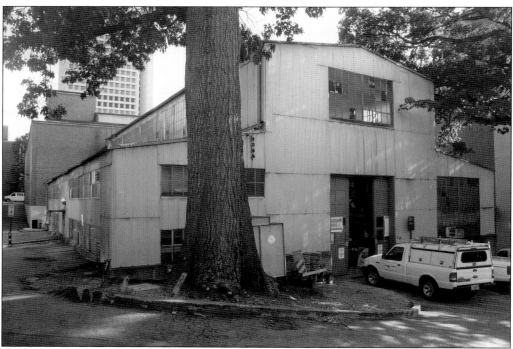

MECHANICAL ENGINEERING RESEARCH BUILDING, 1947 (RAZED). The "Veterans Education Facility," also known as the Tin Building, was originally a US Army ordnance repair shop, probably for large mechanized equipment such as tanks, adapted in 1947 as additional lab space for mechanical engineering research. The building served student competition organizations from the 1990s until 2011. (RMC.)

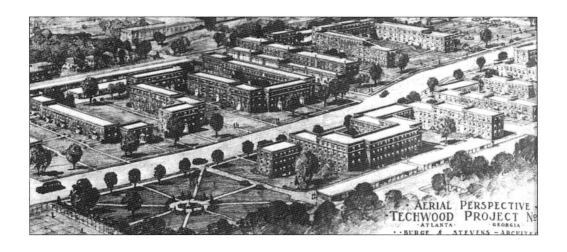

TECHWOOD (MCDANIEL) DORMITORY, 1935 (RAZED). Techwood Homes for whites and University Homes for blacks (near Spelman College) were the first slum-clearance, federally funded, public housing projects in the United States. Dedicated on November 19, 1935, by President Franklin D. Roosevelt, Techwood Homes comprised 43 housing units in setback wings and a dormitory that Georgia Tech rented from 1935 until 1956 and then purchased from the government. Burge and Stevens's housing project provided the latest of domestic amenities, and demand for occupancy was high. However, as the neighborhood declined in the 1960s and after, the dormitory became less desirable as a safe student residence, and by the eve of the Centennial Olympics, the complex was perceived as a slum and demolished, replaced by better housing for Atlantans and a new "university village" for students. (Above, Stevens and Wilkinson; below, GTA.)

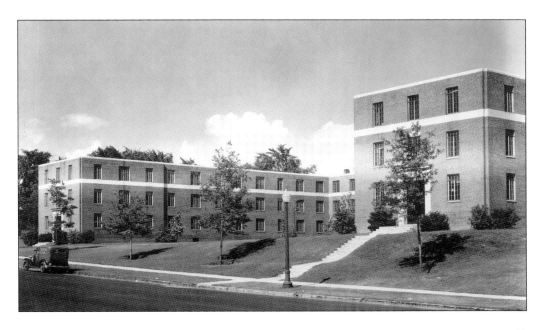

HOWELL/HARRISON DORMITORIES, DON QUIXOTE, 1938–1939.
Two dormitories of the late 1930s expanded Bush-Brown and Gailey's east campus enclave of Collegiate Gothic residential halls immediately surrounding Brittain Hall. The mirrored footprint of the two dormitories along Williams Street today borders the interstate connector. Funded by the PWA, the projects feature artwork by Julian Harris: sculptural reliefs of Don Quixote inset atop the multi-lighted east window bays. Trimmed in stone and the most prominent feature of the east elevations, the bay window is flanked by an arched entry door with foliate carved limestone spandrels; stone trim continues above to enrich upper stories, whereas fenestration elsewhere is without trim except for stone stills. (RMC.)

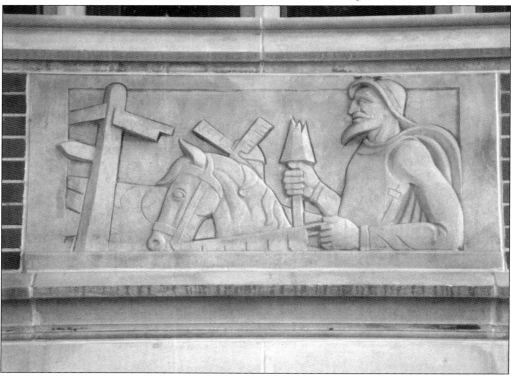

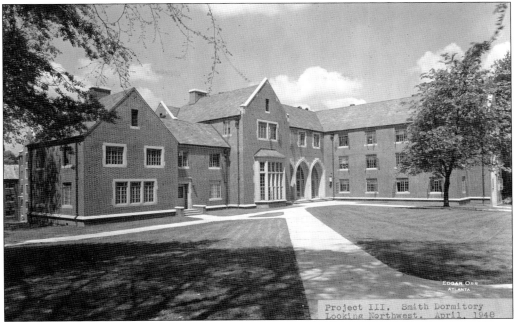

JOHN M. SMITH DORMITORY, 1947. Despite the postwar date, by which time the campus architects Bush-Brown, Gailey, and Heffernan were already moving to a functionalist "Bauhaus" aesthetic in Heffernan's designs for the Textile Engineering Building, the site at the south end of the "east campus" dormitory group dictated a continued, although restrained, neo-medieval brick aesthetic for Smith Dormitory. Smith's setbacks and gables contribute to its added picturesqueness. (GTA.)

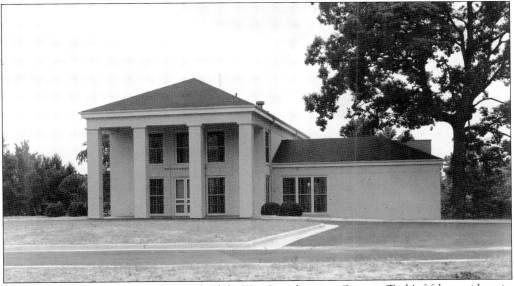

PRESIDENT'S HOME, 1948–1949. Col. Blake Van Leer became Georgia Tech's fifth president in 1944 and was responsible for the building of a new President's House in 1948. His wife sketched the plans, and architects Toombs and Creighton drew up working drawings for the building's construction. Its Neoclassicism (a rationalized Greek Revival) blends modern and traditional architecture. (GTA.)

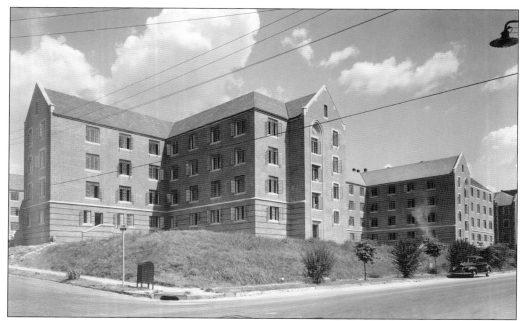

TOWERS AND GLENN DORMITORIES, 1947. Glenn and Towers Dorms site traditional brick gabled forms east and west of an extended courtyard or open quadrangle. At the north end, a new connecting glass structure was added as part of the 2013 renovation, providing exercise and meeting rooms, study lounges, and a joint lobby. Notable in the lower elevations of the 1947 dormitories are parallel projecting brick courses recalling the "lines of speed" of the era's Streamlined Moderne. The recent removal of inappropriate windows from a previous renovation is lauded. In a 2017 "ultimate ranking of freshman dorms at Georgia Tech" by *Society19*, Towers and Glenn dormitories were judged number one: "the beacon, the ultimate . . . truly the Ritz Carlton(s) of Georgia Tech student housing." (Above, GTA; below, RMC.)

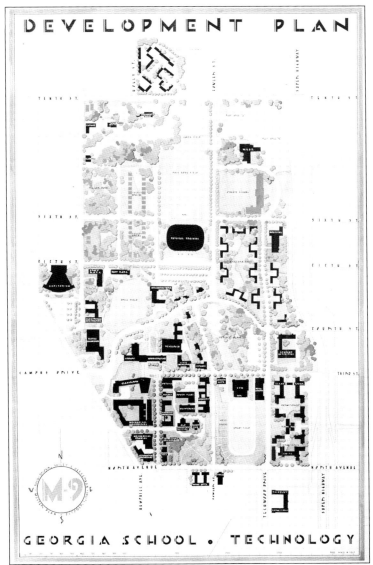

M-9 Development Plan, 1947. For several years after 1944, Bush-Brown, Gailey, and Heffernan participated in the formulation of numbered "M" development plans that focused on the expansion of campus grounds northward. By 1947, the date of the M-9 development plan, projected development assumed Fourth Street would cross over the downtown freeway and, as a major campus street, lead to Heffernan's planned modernist academic village. While a decision to build the freeway bridge at Fifth Street instead compromised this planning, other developments indicated a real change in the evolution of campus architecture during the later 1940s, contributing to a shift to Modernism. The upgrade of the Department of Architecture to a school of architecture in 1948 placed architecture as equal to other schools within the College of Engineering. Moreover, the hiring of three new faculty members—Jim Edwards, Thomas Godfrey, and Samuel T. Hurst, who had been students of Walter Gropius at Harvard—evidenced that architecture pedagogy was embracing the modern Bauhaus approach to design. Paul Heffernan's functionalist architecture would emerge as the dominant campus aesthetic of the following period. (GTA.)

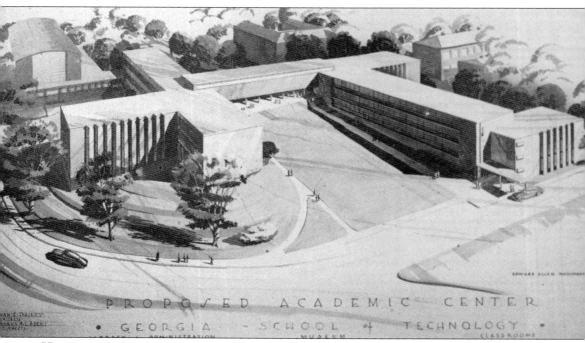

PROPOSED ACADEMIC CENTER

GEORGIA · SCHOOL of TECHNOLOGY ·

HEFFERNAN'S ACADEMIC CENTER PROJECT, C. 1945. One would have thought that Paris Prize winner Paul Heffernan, after two years studying at the Ecole des Beaux-Arts in Paris, would bring a conservative point of view both to his new faculty position at Georgia Tech as well as to his architectural practice with Bush-Brown and Gailey, perhaps discouraging progressive tendencies toward a Modern Classic aesthetic already evident in Georgia Tech student projects of the late 1930s, as well as in Bush-Brown and Gailey campus projects of the period (Heisman Auditorium, for example). However, Heffernan was already showing strikingly progressive tendencies in his Paris student projects, and he would inaugurate his Georgia Tech architectural practice in 1939 with a distinctly modern research building (Hinman), followed by the functionalist architecture of his textile engineering, architecture, and library buildings. These, together with his proposed but unbuilt central academic center, would constitute a modern academic village, sited on and off Hemphill Avenue and Fourth Street, creating the new campus center envisioned in the M-6- through M-11 campus development plans. (GTA.)

Four

PAUL M. HEFFERNAN'S FUNCTIONALIST ACADEMIC VILLAGE, 1946–1961

Architect Paul M. Heffernan was educated in the Beaux-Arts tradition, first at Iowa State University, then Harvard, and finally at the Ecole des Beaux-Arts itself in Paris. It may appear surprising, therefore, that he led the transition away from classical and even traditional historicist architecture in general to a more progressive Modern architecture both as a practitioner and educator at Georgia Tech. It was a sign of the times that functionalism and a more abstract aesthetic, the emphasis on volume over mass and ornamented form, would color Heffernan's work of the late 1940s and 1950s on campus, reflective of what since 1932 had been labeled "the International Style."

The term derives from Philip Johnson and Henry-Russell Hitchcock Jr.'s exhibit at the Museum of Modern Art in New York and their subsequent book, *The International Style: Architecture Since 1922* (published by W.W. Norton in New York in 1932). The book surveyed the new European "white" architecture of the 1920s and 1930s considered in large part to evolve from the Bauhaus in Germany. Heffernan disliked labeling his modern campus buildings either "Bauhaus Style" or "International Style," preferring to emphasize their functionalism by which design responds directly to client need and building purpose and use. A new spirit was immediately in evidence in Heffernan's Research Building of 1939, and Bauhaus influences and the functional zoning of his postwar buildings were made manifest in what became known as Heffernan's functionalist academic village, his signature work of the late 1940s and 1950s. This transition was what Bush-Brown had called the architectural revolution from Beaux-Arts to Bauhaus, and Georgia Tech's architecture faculty was leading the way.

Heffernan inaugurated the new campus aesthetic with his Research Building for the Georgia Tech Engineering Experiment Station (the predecessor to GT Research Institute); known today as the Hinman Building (1939), it is now part of the College of Design. Its high bay loosely echoed the industrial character of Peter Behrens's AEG Turbine Factory in Berlin (1909), a pioneer modern work recognized early by Nikolaus Pevsner in his *Pioneers of Modern Design: From William Morris to Walter Gropius* (published by Faber and Faber in London in 1936). Both buildings were industrial in character and scale, expressive of technology in their detailing and direct display of modern materials, and monumental in traditional ways without traditional styling. Within Hinman's vast interior at Georgia Tech, research contributed to advances in helicopter design, to the development of microwave technology, and more recently, to innovative and technology-based architectural design.

Heffernan then turned to a series of buildings that would loosely be referred to as his Modern academic village: the Textile Engineering Building (1948–1949, razed), the Architecture Building (1952), and the Price Gilbert Library (1951–1953), the latter intended to be connected by a bridge to an administrative wing and classroom building. With its ribbon windows, sun screens, open

volumes, and functional design, Heffernan's modern campus architecture offered Georgia Tech and the South a new direction: a postwar functionalist modernism that garnered attention in the national architectural press.

As Heffernan turned to the final design of his administration wing and classroom building, projected as early as 1945, the long-standing practice of Georgia Tech's campus architecture's being designed by the architecture department was brought into question by A. Thomas Bradbury, an architect and lawyer. He argued that architects on the faculty had their office overhead paid for by Georgia Tech, they could turn to students for drafting assistance, and they benefited from an unfair advantage over professional architects seeking to submit competitive bids for campus jobs. Concerned that legal action might ensue, Georgia Tech terminated its "in-house" practice, in place since the days of Francis Smith, by which the engineering school had turned to its architecture faculty for the design of campus buildings. The classroom building that Heffernan projected in his academic center design was awarded to Bradbury, who then designed and built a Heffernan-inspired structure. Bradbury subsequently embarked on a renewed career in extensive government work throughout the 1950s, designing the several state administration buildings (for the departments of agriculture, health, transportation, labor, and more) that today surround the Georgia state capitol in downtown Atlanta, as well as the state archives building (razed) and the governor's mansion in Buckhead. In 1957, Bush-Brown retired, and Heffernan took over as director of the school's architecture department and essentially closed his architectural practice. Paris Prize–winner Paul M. Heffernan, one of Atlanta's most progressive and talented architects, was now dedicated exclusively to architectural education and would never build again, with the exception of the 1961 redesign of his own house on campus (a 1923 bungalow that he modernized), and the collaborative design with a former student, Sam T. Hurst Jr., of the Wesley Foundation (1960).

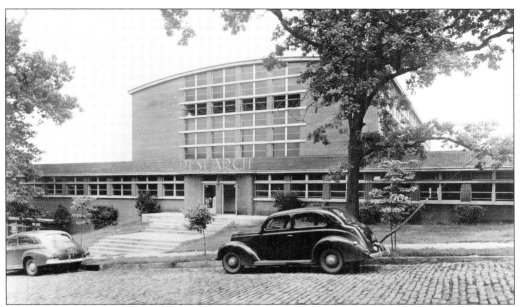

HINMAN RESEARCH (GEORGIA EXPERIMENTAL STATION), 1939. Heffernan's research building is both monumental and industrial, calling to mind Peter Behrens's pioneer modern AEG Turbine Factory of 1909 in Berlin, Germany. Hinman features a 50-foot "high bay" industrial shed with a 10-ton-lifted-load-capacity bridge crane originally installed to roll overhead along steel rails for use in supporting and moving large equipment as when the research space served activities associated with helicopter development. Heffernan was 29 when he designed Hinman and already progressive as evidenced by the building's Moderne entry and contemporary graphics; his modern spirit continued in a subsequent ribbon-windowed addition, a building kept low around the base in order to maximize the mammoth scale of the 1939 envelope and spatial volume behind. (GTA.)

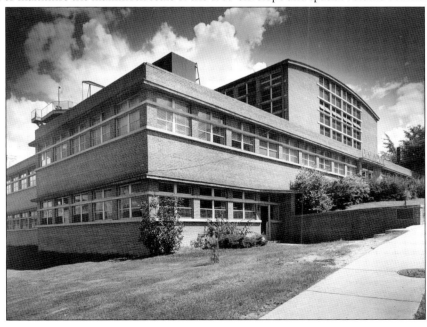

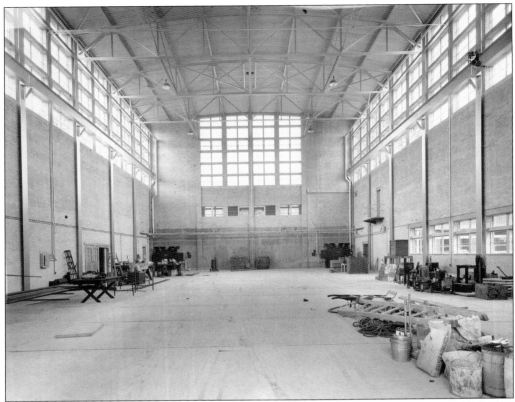

HINMAN RESEARCH BUILDING, RENOVATION, 2011. The award-winning 2011 renovation (below) of the Hinman Building adapted the high bay and flanking spaces to graduate studios in architecture and industrial design, including space for computer labs, the architecture library, and classrooms. The high bay crane now suspends by slender rods a 24-by-53-foot mezzanine "crib," adding additional studio space mid-height. Noted for its flexibility, the high bay accommodates open design studios, "jury" critiques, and exhibitions; provides a venue for informal and formal public use such as graduation, parties, and receptions; and offers space even for movies and lectures for which a 32-foot-wide vertical lift door serves as pinup wall, video screen, or classroom PowerPoint projection screen. (Above, GTA; below RMC.)

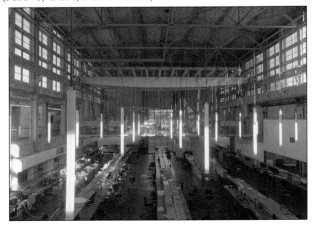

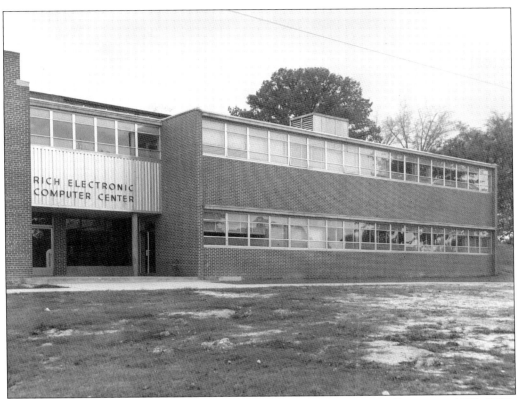

AC Network Calculator Building, 1947/Rich Electronic Computer Building, 1955–1956.
When Georgia Tech acquired a huge AC network calculator (an ancestor of the modern computer), it was initially housed in a 1947 building designed by Bush-Brown, Gailey, and Heffernan, later developed by A. Thomas Bradbury as the Rich Electronic Computer Building, the whole eventually enveloped in Cooper Carry's Rich Computer Center of 1973. (GTA.)

W.C. and Sarah Bradley Building, 1951. Although Georgia Tech tried to persuade the Bradleys to fund a fountain at the Hemphill Avenue/Fourth Street entrance to campus, in order to add some beauty to a strictly utilitarian campus, their donated funds constructed, instead, a luncheon building behind "Tech Tower" designed by Bush-Brown, Gailey, and Heffernan. It later became popular as Junior's Grill. (RMC.)

APARTMENT PROJECT FOR GEORGIA TECH

BURGE AND STEVENS AND ASSOCIATES
ARCHITECTS AND ENGINEERS, ATLANTA, GA.

FLIPPEN D. BURGE APARTMENTS, 1946–1947 (RAZED). Named for architect and 1916 Georgia Tech alumnus Flip Burge, the Burge Apartments served married students without children and faculty members with older children. Noted for its innovative design, the building reflected a changing perspective at the firm: an "effort to substitute for the senseless continuation of inappropriate traditional styles a more gracious and pleasant mode of existence in which maximum advantage may be taken of sun light, openness, view, and a closer relation of indoor and outdoor living." Both radiant floor heat and convection heating were used in different areas of the building as a study of the relative benefits of each. On the exterior, cantilevered sun screens on the south and west elevations and balconies with pipe-rail railings on the north façade were the only features contrasting with the smooth brick exterior. The unadorned windows of the economical, functional, and geometric building featured double-hung aluminum sash and screens. The whole was a clear reflection of an emerging progressive architecture for Georgia Tech. (GTA.)

CALLAWAY APARTMENTS, 1947, ARCHITECT'S AERIAL RENDERING (RAZED). In 1946, Tech architecture professor J.H. Gailey observed, "It has long been the feeling that Gothic doesn't suit a modern . . . apartment building. Both classrooms and apartments need more adequate lighting, natural and artificial, than possible in Gothic buildings." Callaway Apartments, housing married students with small children up to high school age, was an early reflection of this progressive view. (GTA.)

CALLAWAY APARTMENTS, 1947 (RAZED). Both Burge and Callaway Apartments were published in the March 1947 issue of *Architectural Record*, and six months later, Burge Apartments was featured in *Architectural Forum*. The architects of Tech's architecture department had been constrained by contextual issues at their "Gothic" Smith Dorm of 1947, contemporary with Callaway, but would not be in Heffernan's progressive Textile Building soon to rise as the first structure of the planned modern academic village. (Stevens and Wilkinson.)

HIGHTOWER TEXTILE ENGINEERING BUILDING, 1948–1949 (RAZED). Paul Heffernan's Textile Engineering Building was the first of his several "functionalist" buildings on campus, adapting Bauhaus imagery and planning strategies to postwar architecture at Georgia Tech and projecting an "academic center" sited north of the historical sections of the campus. Although preceded by his 1939 Research Building (for the Experimental Engineering Station, now Hinman), the 1948–1949 Textile Building and 1952 Architecture Building, as well as Heffernan's 1953 Price Gilbert Library and his projected administration "bridge" with classroom structure attached, were progressive designs influencing a younger generation of architects. These students and Heffernan contemporaries went on to build science buildings, church fellowship halls, and office buildings throughout the city of Atlanta as well as statewide public schools, all in the Modern idiom. (GTA.)

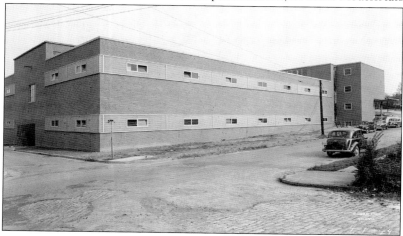

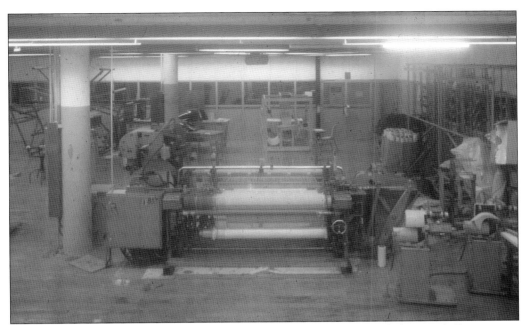

INDUSTRIAL WING, TEXTILE ENGINEERING BUILDING. Functionally zoned, the Textile Engineering Building separated its glazed classroom wing from its industrial production wing, the latter enclosed by brick and glass block and containing the full assortment of textile equipment and dedicated rooms for carding, spinning, weaving, and more. (RMC.)

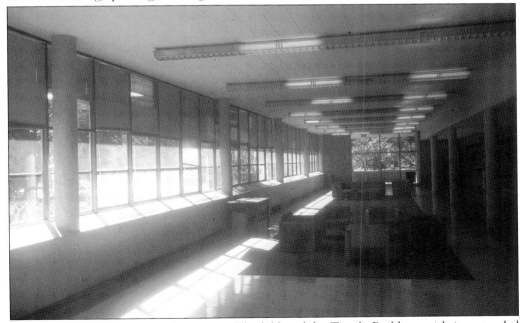

LOBBY, TEXTILE ENGINEERING BUILDING. The lobby of the Textile Building, with its extended ribbon window, presents a classic image of the Modern interior: volumetric, enveloped by planes, stripped of ornament, and full of light. It provided a public space convenient to both the building's entry and auditorium, with classrooms above. (RMC.)

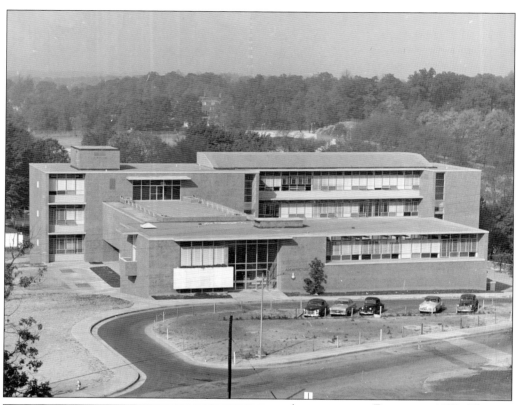

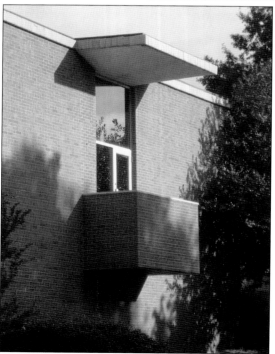

ARCHITECTURE BUILDING, 1952. The Architecture Building was the first in the United States to be built for and designed by a campus architecture department. With its separated administrative and public south wing, its library "bridge," and its four levels of stacked north-wing studios, it is Heffernan's most significant exemplar of "functional zoning," inspired by the Bauhaus in both planning and aesthetic. (GTA.)

DIRECTOR'S OFFICE BALCONY, ARCHITECTURE BUILDING. Nicknamed "the papal balcony," the slab-canopied balcony extending from the school director's office provided a platform from which the director of the architecture school could "pontificate" to his students and faculty gathered in the courtyard below. This front wing of the Architecture Building was reserved for public functions; the auditorium is on the ground floor, and an exhibition hall and the director's office above. (RMC.)

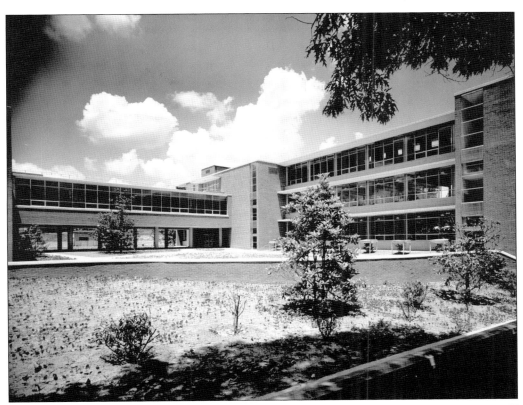

COURTYARD, SOUTH ELEVATION STUDIO WING, ARCHITECTURE BUILDING. Sensitive to passive solar issues, Heffernan provided a studio wing of single room depth so that an expansive glazed wall on four levels provided north light into studio spaces while the south elevation, overlooking a courtyard, was shaded by continuous slab sun screens. (GTA.)

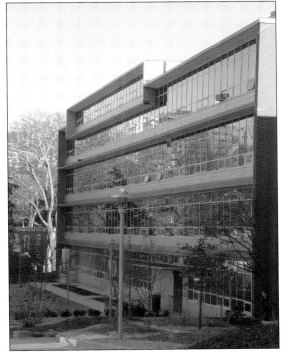

NORTH ELEVATION, STUDIO WING, ARCHITECTURE BUILDING. The studio wing provided a ground-level woodshop and studio for the industrial design division with studios for architecture students above, with the top floor designated for senior architectural and thesis design. The north face features a remarkable open wall of glass, where students worked until midnight and whose nighttime electrical lighting is said to provide a landmark for pilots approaching Hartsfield Airport. (RMC.)

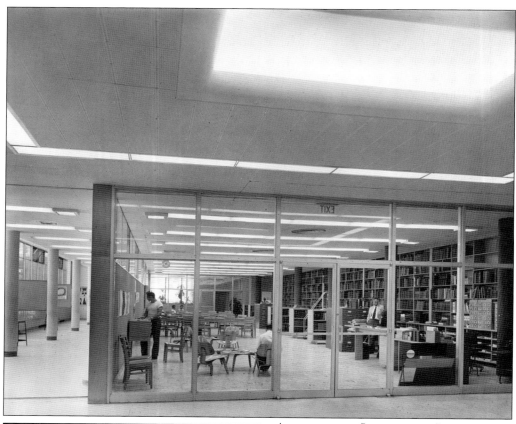

ARCHITECTURE LIBRARY AND LOBBY, ARCHITECTURE BUILDING. The architecture library was housed on the bridge connecting the public and studio wings of Heffernan's Architecture Building. Its then small collection of books was housed on shelving against the windowless brick west wall. Natural lighting entered from the east by way of corridor windows beyond the library's partially glazed east wall. When the library was moved to the new west wing, the space was subdivided for offices, but Heffernan's classic Modern interior was later reinstated under architecture dean Alan Balfour, although again, regrettably, recently chopped up for offices. Balfour also installed Julian Harris's *Pygmalion* sculpture in the lobby. Designed as a maquette for one of two larger figures intended for the west exterior wall of the main campus library, this cast-aluminum figure was given to Heffernan by the sculptor. (Above, GTA; left, RMC.)

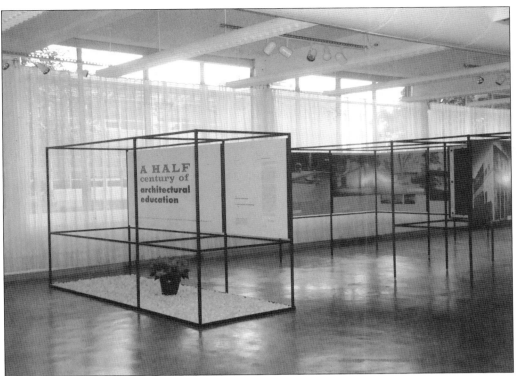

EXHIBITION HALL AND AUDITORIUM, ARCHITECTURE BUILDING. Although adopted in later years for graduate studio space, the exhibition hall was intended as a public venue for traveling art and architecture exhibits. Bush-Brown arranged for several shows sponsored by the Smithsonian Institute, but a major exhibit of his final years as architecture director was the *A Half Century of Architectural Education* exhibit of 1955, illustrating projects of graduates of the architecture school. The panels survived, and the exhibit was remounted by Alan Balfour in 2012, celebrating the 60th anniversary of Heffernan's Architecture Building. The restoration of Heffernan's auditorium below was another effort of Balfour, who sought eventually to renovate the entire building. Sensitive to Heffernan's original design, the auditorium was brought up-to-date with today's technology in a project led by architect and alumnus Jim Choate of Surber Barber Choate Hertlein. (RMC.)

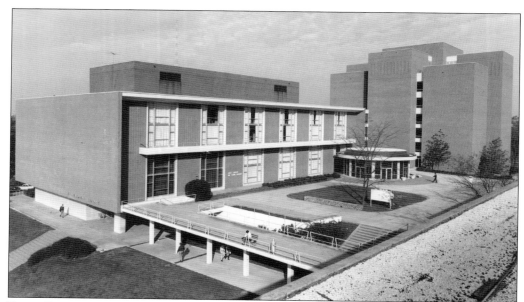

PRICE GILBERT MEMORIAL LIBRARY, 1951–1953. The orientation of the original library design projected north/south wings but was turned 90 degrees, leaving an unadorned and windowless brick wall on the west (to protect the book stacks against direct sunlight), a south face protected by smaller windows and a continuous lintel and sill serving as sun screens, and a window wall on the north side lighting the double-height reading rooms, the central focus of the library interior. The main entry was later moved to the easternmost bay of the south front accessed by way of a rotunda and with the library forecourt further enriched in 1976 by a modern sculpture and fountain, both recently removed. The north front, like Heffernan's architecture studio wing, is a full-height wall of glass. (GTA.)

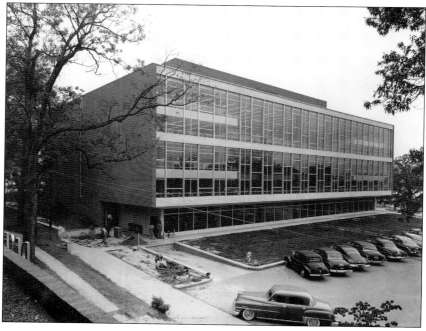

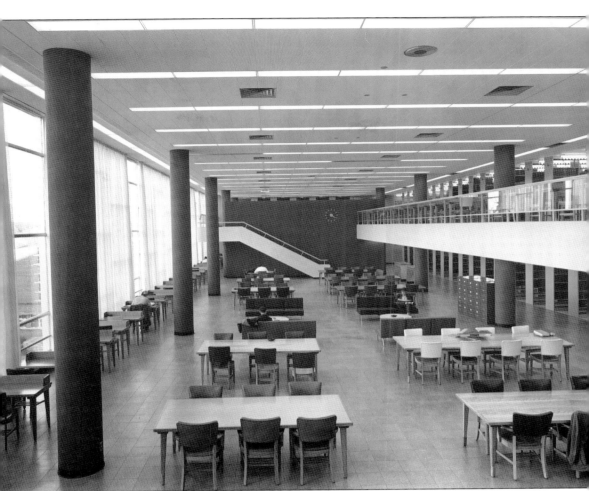

READING ROOM, PRICE GILBERT LIBRARY. The Price Gilbert Library's stacked, double-height reading rooms are two of the finest Modern interior spaces in Atlanta. With the building's large and open north window wall, simply composed staircases and abstract clock faces on each end wall, and the continuous balconies and interpenetration of stacks space along the south edge above the circulation desk, the reading rooms are economical in design, progressive in spirit, and highly functional as commons spaces within the academic library. Modern furniture originally included intimate carrels along the sides, broad tables in the center space, and an occasional round table with chairs for quiet group conversation or collaborative study. Special reception rooms, archives, and special collections were just off the lower reading room with the library's main book stacks, always open, organized on several levels off both major spaces. More recently adapted to computer workstations, the *Gesamtkunstwerk* has lost its unity, a disadvantage considered predictable for an institution moving toward a 21st-century library without books. (GTA.)

Two Late-1950s Buildings. In the 1940s, Bush-Brown, Gailey, and Heffernan prepared plans for a new building for campus radio station WGST intended to be built on the highest site on campus, a location that became the site of the president's house instead. The promised building, constructed to a different BBGH design on Eighth Street, was subsequently used by campus student-run radio station WREK from 1978 to 2004. Other late 1950s buildings, although considered less distinguished works, continued the Heffernan tradition of campus modernist architecture. In 1957, Heffernan's student John Cherry (class of 1940) designed the Aeronautical Engineering Shop Annex subsequently incorporated into his Knight Building in 1967. In 1959, the Roy S. King Physical Plant Building (below) was completed by campus architect David Savini, working with 1943 Tech alumnus William Roy Tapp Jr. (GTA.)

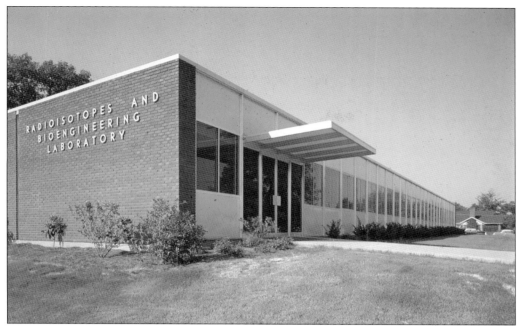

RADIOISOTOPES BIOENGINEERING LABORATORY (CHERRY L. EMERSON BUILDING). In 1959, architect John Cherry's Radioisotopes Bioengineering Laboratory appeared as a one-story building, erected to receive, store, and process radioactive materials and to serve Georgia Tech's emerging programs in nuclear engineering. Two years earlier, the Georgia Legislature had approved a grant for constructing a reactor on campus, and the Neely Nuclear Reactor was built between 1961 and 1963. In 1967–1968, Cherry added a second and third floor to the Radioisotopes building for the School of Nuclear Engineering and for the biology department, respectively. After the decommissioning of the reactor (see page 72), the Cherry Emerson Building has been fully occupied by the biology department. (GTA.)

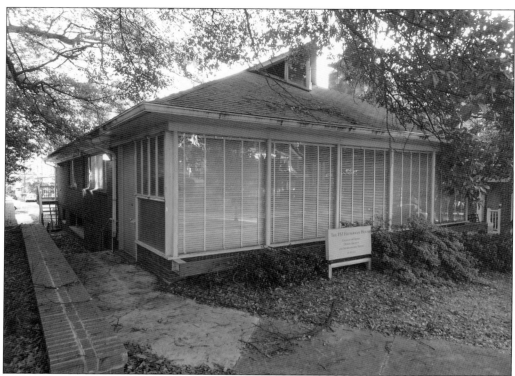

PAUL HEFFERNAN HOUSE, REMODELED 1960–1961. The residential neighborhood that was slowly supplanted by Georgia Tech's campus contained wood-framed bungalows, not unlike those remaining in the Home Park neighborhood north of campus today. One such gabled house, likely dating to 1923, was later purchased by Paul Heffernan and remodeled by him in 1960–1961. A lifelong bachelor, Heffernan lived here until his death in 1987, sharing the house for a time with his sister Virginia Hancock, an artist, as well as with art historian James Grady who occupied a remodeled basement apartment and who taught at the architecture school. Heffernan's redesign created a north street front of glass. An enlarged living room/reception space contained Heffernan's book and record album collection, and his museum-quality Art Nouveau Gallé glass collection was exhibited in modern display cabinets across the south end of the room. (RMC.)

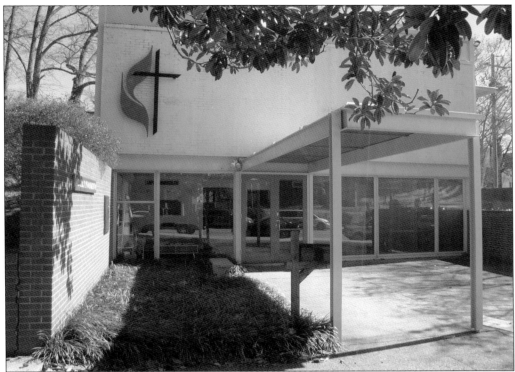

WESLEY FOUNDATION, 1960. The Wesley Foundation building was the last campus building in which Paul Heffernan took an active role as a practicing architect, working here with his former student, Sam T. Hurst Jr. Aesthetically, the Wesley Foundation building looks more to Mies Van der Rohe than to the Bauhaus and Gropius whose work had earlier influenced Heffernan. A rectangular great room of floor-to-ceiling glass encased within a structural frame of exposed steel posts and beams appears to float above a moat-like depression, crossed by a short bridge to the upper entry. A rhythm of angular arches positioned like a valance along the south front suggests a New Formalist counterbalance to the Miesian glass and frame below. (RMC.)

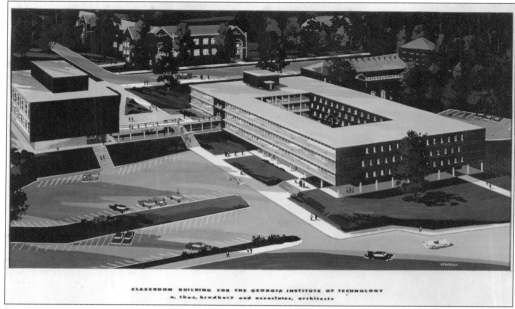

CLASSROOM BUILDING FOR THE GEORGIA INSTITUTE OF TECHNOLOGY
a. thos. bradbury and associates, architects

SKILES CLASSROOM BUILDING, 1959. Although wrongly attributed elsewhere to Paul Heffernan, the Skiles Classroom Building is the work of A. Thomas Bradbury. Bradbury's objections to the long tradition of Georgia Tech's awarding campus commissions to architects on its faculty prompted the end of the practice and essentially closed the active architectural practice of Paul Heffernan. Heffernan would henceforth dedicate his professional life to administration and teaching, notably critiquing "fifth year design," the culminating undergraduate studio. Heffernan's several functionalist campus buildings certainly influenced Bradbury here, especially in adopting sun screens at Skiles that are almost identical to those on the south courtyard elevation of Heffernan's Architecture Building. Heffernan's projected administration and classroom center, which he intended to join as wings to his library, was transformed by Bradbury to this enlarged free-standing classroom structure, built in Heffernan's image. (Above, GTA; below, RMC.)

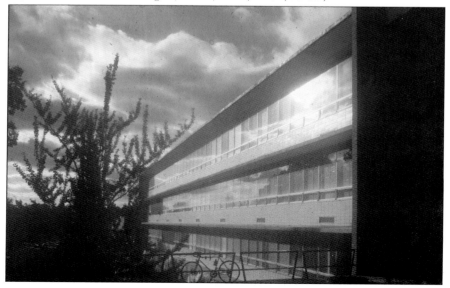

SKILES CLASSROOM BUILDING, 1959. Raised pedestrian walkways, platforms, and interpenetrating corridors with coffered ceilings slice through Skiles Classroom Building like abstract planes in a De Stijl design. With joined wings forming a courtyard, elevations vary across the building: in contrast with the open, sun-screened south front, the west elevation's small windows create a more Formalist façade pattern which varies from open ribbon windows of 1940s and 1950s Modernism, a difference that acknowledges the harshness of the late-day sun heating the west façade. Architect Bradbury's eclectic Atlanta work is prominent in the group of Modern Classic mid-1950s state office buildings surrounding the state capitol; the exotic Yaarab Shrine Temple, 1963–1965, on Ponce de Leon Avenue; and the Greek Revival governor's mansion, 1964–1967; the latter two designed after Skiles. (Above, RMC; below, GTA.)

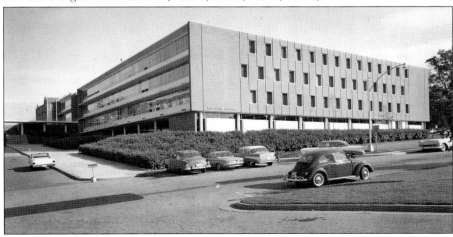

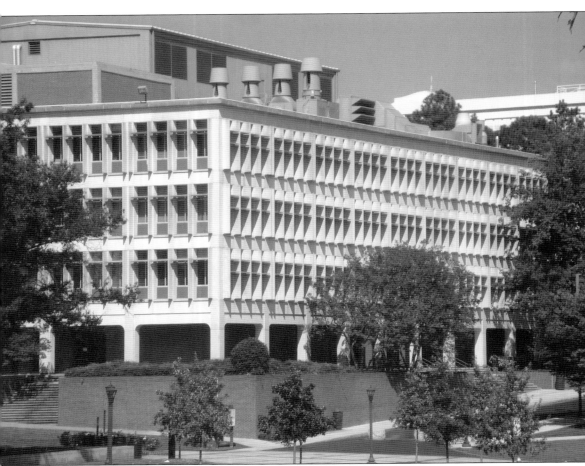

BUNGER-HENRY BUILDING, 1964. The architectural aesthetic dubbed New Formalism arrived on campus with John Portman's Whitehead Infirmary (1960), the Electrical Engineering Building (1961), the Nuclear Reactor (1961–1963), and the Bunger-Henry Chemical Engineering and Ceramic Engineering Building (1964, above). A Formalist building, as the term implies, articulates the substance (structural frame, stylized skin, ornamented walls) of a building's form in reaction to the volumetric abstraction and planar skins of earlier Modern buildings (as in Midcentury Modern buildings influenced either by the Bauhaus or especially "glass boxes" by Mies Van der Rohe). Prominent architects such as Edward Durrell Stone and Minouri Yamasaki brought a renewed historicism to their styled "temple" buildings, which were both modern and ornamental, stylized and Mannerist, frequently reshaping columns and arcades in unorthodox profiles as they surrounded otherwise plain office blocks; Formalist buildings now preened in their new stylish architectural dress. Representing a more-conservative Formalism at the Bunger-Henry Building, the architects of Finch, Alexander, Barnes, Rothschild and Paschal (FABRAP) articulated the structural frame, sun screens, and deep-set windows, creating a rich repetitive surface highlighted by contrasts of light and shadow. (RMC.)

Five

FROM SCHOOL TO COLLEGE OF ARCHITECTURE, THE 1960s–1994

Georgia Tech campus architecture during the 1960s through the 1980s reflected the changing styles of the period, which ranged from New Formalism and New Brutalism to Post-Modernism. The first may be considered a reaction to the Miesian Aesthetic that dominated commercial office buildings during the 1950s, a glass-and-steel architecture in which structural steel frame and glazed surfaces revealed a volumetric architecture that some dismissed as "glass boxes." Architect Ludwig Mies Van der Rohe set the pace on the campus of the Illinois Institute of Technology, and such late examples in Atlanta as Skidmore Owings and Merrill's Equitable Building (1968) downtown may be considered, still, Miesian, but by that late date Formalism was dominating. The Wesley Foundation (1960) and an upper terrace wall of the 1955–1956 Rich Computing Center on campus come closest to being "Miesian," while the Presbyterian Center (designed 1965, built 1968–1969) and Baptist Student Center (designed 1964, built 1968–1970) are both more Formalist. The entry lobby and staircase of the Bunger Henry Chemical Engineering and Ceramic Engineering Building (1964) on campus also looks to Mies, but in its exterior forms, the Formalist Bunger-Henry building more distinctly emphasizes plastic form over spatial volume adopting sun screens and structural frame to conspire with light and shadow to express the formal richness of the building. The pierced and color-glazed brickwork at Robert and Company's Blake Van Leer Electrical Engineering Building (1961) across the street joins Bunger-Henry's façade recesses and expressions of form defined by light and shadow, displaying varied compatibilities with the emerging New Formalism of the day, but neither building turns to stylized columns, expressive temple forms, or distortions of classicism or other historicist forms, to announce the building's new formalist intentions.

Brutalism is more directly reflected at Emory and at Colony Square's residential blocks in Atlanta, but on Georgia Tech's campus, raw gestures inspired by New Brutalism are best expressed in the West Architecture Building (1980) by Cooper Carey. The exterior, with its open and sculptural concrete exterior staircases and corrugated chipped concrete skin, looks for inspiration to master builder Le Corbusier by way of Paul Rudolph's Art and Architecture Building (Rudolph Hall) at Yale (1963). Reflecting an intention that the building serve as a teaching aid for architecture students, Jerry Cooper exposes the mechanical systems (heat/air ducts, piping, and, later, data wiring tracks) and makes visible the waffle ceiling, concrete posts, and concrete block (cmu) construction that partitions off classroom and restroom spaces. Reyner Banham had illustrated similar exposures of the guts of the buildings at Alison and Peter Smithson's Hunstanton School (1949–1954) in England in his defining writings on New Brutalism first appearing in article form as "The New Brutalism," (*Architectural Review*, December 9, 1955) and then in book form by Banham: *The New Brutalism: Aesthetic or Ethic?*, published in New York by Reinhold in 1966.

Architect Cooper's intentions were explicitly didactic in the naked display of building parts and mechanical systems at Georgia Tech.

Post-Modernism, then, reacted to these and other tendencies of technology-oriented modernism by arguing for a more inclusive architecture and embracing vernacular as well as sophisticated historical precedents. The latter was sometimes merely paper-thin as buildings began to take on a veneer of a new historicism. For a Beaux-Arts ball in the 1980s, students of the architecture school literally gift-wrapped the connecting bridge that joined Heffernan's Architecture Building with Cooper's West Wing. The new skin draped both buildings with a painted-on-paper classicism, offering the critical commentary that the new historicism was mere upholstery, history had become ornament, and Post-Modernism was insubstantial, a preview of a forthcoming virtual world.

In "real" Post-Modern architecture at Georgia Tech, color patterns and both abstract and referential ornament returned to enliven building facades at Jova Daniel Busby's campus buildings: at the Wardlaw Building (1986–1988), where stone insets suggested abstract profiles of Tech Tower and at the College of Computing Building (1989) where varied brick tones displayed a renewed appreciation of color in architecture. Terry Sargent of Lord and Sargent (now Lord Aeck Sargent) introduced a host of historical references in his Manufacturing Research Building of 1988–1991, including gestures of sheer wit of the kind that Charles Jencks recognized in his 1977 book *The Language of Post-Modernism* (published by Rizzoli) as a renewed Vitruvian delight of Post-Modernism.

During these decades, the architecture department moved from a department and school within the College of Engineering to an independent College of Architecture, with William Fash appointed the first architecture dean in 1977 and Tom Galloway taking the leadership position in 1992. Two years later, Georgia Tech alumnus G. Wayne Clough would return to his alma mater as Tech's 10th president, and architecture on campus would never be the same.

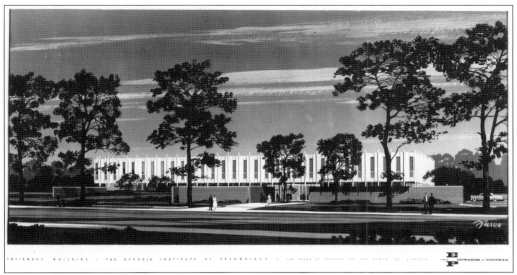

WHITEHEAD MEMORIAL INFIRMARY, 1959–1960 (RAZED). The Whitehead Infirmary was an early work of John Portman, a 1950 graduate of Georgia Tech's architecture school, who (following a three-year apprenticeship with Stevens and Wilkinson) briefly opened his own firm in 1953 before forming a partnership in 1956 with his former teacher, H. Griffith Edwards. The infirmary was built on the eve of Portman's first buildings for Peachtree Center, a 17-block urban center that Portman developed over the next decades. At the infirmary, the unorthodox narrow and vertical windows set between applied fins that (in the initial design above) extend both below and above the raised building block create an ornamental pattern that is consciously stylized, comparable to the Formalist surfacing of Portman's contemporary 1961 Merchandise Mart, the inaugural building of Peachtree Center. (GTA.)

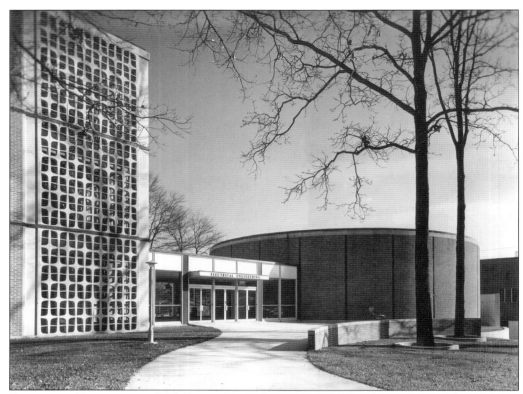

ELECTRICAL ENGINEERING (EE) BUILDING, 1959–1961. Robert and Company architects were likely influenced by Eero Saarinen's MIT Chapel, completed in 1956, in building here a circular auditorium surfaced in brick and connected to the main block of the EE Building by a Miesian entry corridor. Earlier campus auditoriums served both public events as well as large academic lecture courses, and those at both the Textile Engineering and Architecture Buildings were "zoned" and segregated in their dual curricular and public functions. Visible in the photograph below is John Portman's *KR+C* sculpture (2020), a 38-foot-tall white fiberglass work in the aesthetic family of Portman's *The Web* (in the atrium of the architect's SunTrust Garden Offices) and *Aspiration* (in Buckhead's Loudermilk Park). *KR+C* references the phrase "Knowledge and Research plus Creativity," as embodied in Tech's educational and research endeavors. (Above, GTA; below, RMC.)

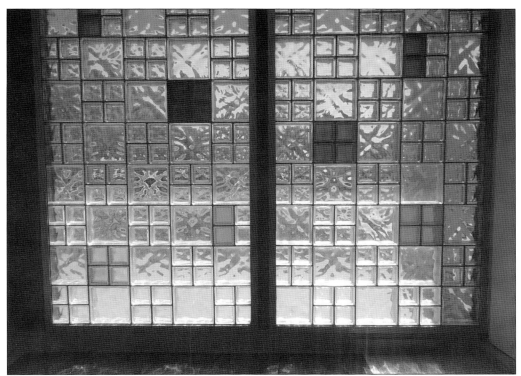

PIERCED TILE WALL, ELECTRICAL ENGINEERING BUILDING. A popular decorative wall treatment during the 1950s was a grill of pierced tile or open brickwork, popularized by Edward Durrell Stone, who admired both its ornamental value and its environmental benefits. At the EE Building, Robert and Company architects enrich the entire south face of the building with an ornamental grill whose perforations are filled with both clear and colored glass, creating notable effects inside by day and outside at night. Architecture's quintessential elements of form, space, and light are given tangible expression in this masterful interplay of design features. (RMC.)

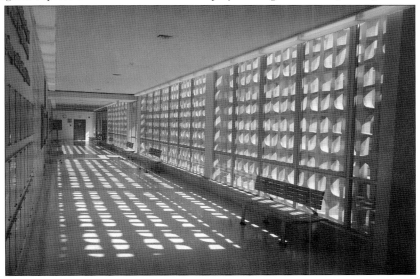

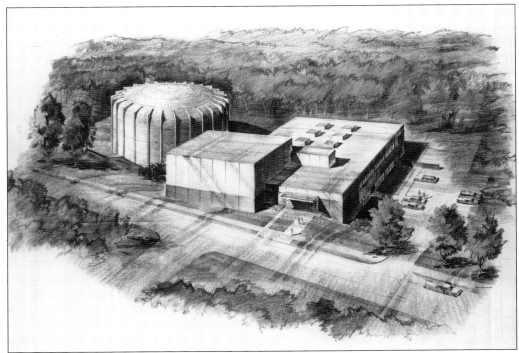

FRANK H. NEELY NUCLEAR REACTOR, 1961–1963. Following a recommendation from a campus nuclear science committee supporting nuclear research, the Radioisotopes Laboratory was erected in 1958–1959, and construction of the Neely Nuclear Reactor was completed in 1963. The five-megawatt heavy water moderated and cooled reactor operated for three decades when it was shut down for safety reasons in 1988 and de-fueled in 1995 on the eve of the Centennial Olympics, ultimately decommissioned in 1997–1999. The nuclear reactor containment building stood vacant for another seven years and was finally razed in 2006 in preparation for the construction of the Marcus Nanotechnology Building. The nuclear reactor project cost $4.5 million to build and $7 million to decommission. (GTA.)

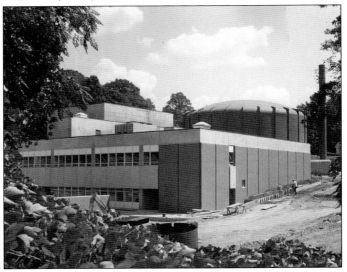

AREA II DORMITORY COMPLEX, 1961. Opening in the fall of 1961 and accommodating 750 students, the Area II Dormitories were already passé in style with their flat roofs, cantilevered flat sun screens over grouped windows, and unrelieved rectangular block forms, an Early Modern vocabulary compatible with Callaway Apartments of 1947, but "dated" a decade and a half later. Composed as a Modernist ensemble, still employing brick but distinctly different from the adjacent east campus's Neo-Jacobean/Collegiate Gothic brick architecture of Bush-Brown, Gailey, and Heffernan, the five units of Hopkins, Hanson, and their adjacent residence halls extended the student housing complex northward across Third Street to the edge of the fraternity house district, completing the "east campus" initiated with Brown Dorm in 1925. (GTA.)

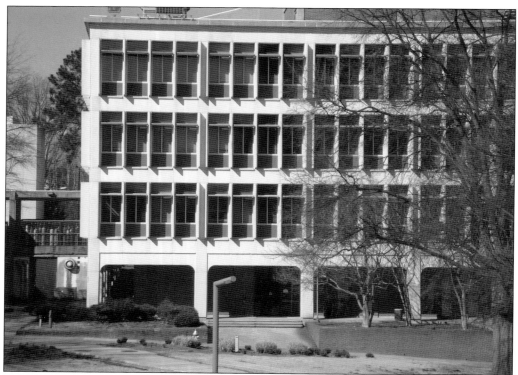

FORMALIST EXTERIOR, BUNGER-HENRY BUILDING, 1964. The Bunger-Henry Building features deep façades of sun screens and recessed windows bringing to the design a formal texture, contrasts of light and shadow, and an ornamented interplay of fenestration and structure. The architects of the progressive firm of FABRAP provide a decorative box to house the chemical and ceramic engineers, employing simple horizontal and vertical precast concrete slabs to allow the sun and shadow to enrich the architectural articulation. FABRAP is an acronym made up of the last names of the principals of the architectural firm, James H. "Bill" Finch, Cecil Alexander, Miller Barnes, Bernard Rothschild, and Caraker Paschal. Finch, Barnes, and Pascal were Georgia Tech alumni, and while Finch and Barnes had been practicing together since 1948, the five-man firm of FABRAP was only six years old when the Bunger-Henry Building was erected. (RMC.)

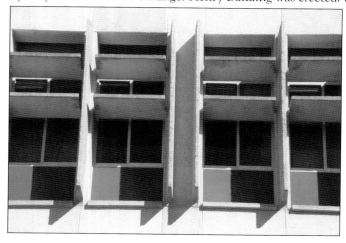

LOBBY STAIRCASE, BUNGER-HENRY BUILDING. The influence of architect Mies Van der Rohe is evidenced in the staircase of the Bunger-Henry entry lobby with its restrained and elegant lines expressing its structure and steel framework directly. At the architecture school, a spring term 1961 student design for a staircase by Kurt Herrman demonstrates a similar interest in Mies's unembellished structural expression, although the Miesian Aesthetic remained generally rare in Atlanta's built work. FABRAP's Bunger-Henry lobby staircase ultimately looks to stairwells at Mies's Illinois Institute of Technology campus, the architect's collegiate complex erected during the several years following his appointment to head the Armour Institute. Mies arrived in Chicago in 1938, the same year Paul Heffernan came to Georgia Tech, and the year after Gropius arrived at Harvard. Mies's minimalist spirit of pristine elegance in industrial materials informs FABRAP's lobby and staircase. (RMC.)

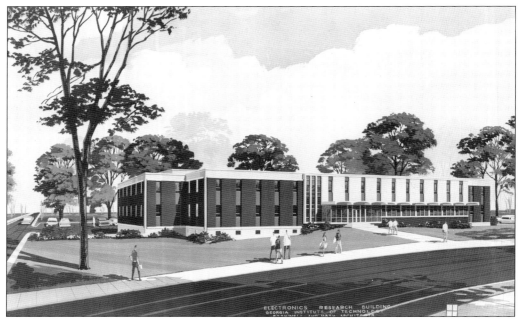

ELECTRONICS RESEARCH BUILDING, 1965–1966 (RAZED) AND BAKER RESEARCH BUILDING, 1969. Established in 1934, the Engineering Experiment Station grew exponentially as the applied research and development arm of Georgia Tech. Renamed in 1985 the Georgia Tech Research Institute (GTRI), it coordinates the research work of 2,400 scientists and engineers engaged in almost a quarter-billion dollars in research annually. The 1965–1966 Electronics Research Building (above) was a two-story structure with a stylish flat-arched concrete arcade shading the glazed entry and lobby. The building was razed to make way for the Marcus Nanotechnology Building. Joe Amisano's 1969 Baker Building (below) remains, however, preserved in its masonry weight and substantiality as the only campus work by one of Atlanta's most noted form-makers. (GTA.)

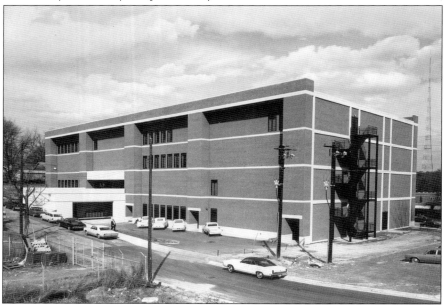

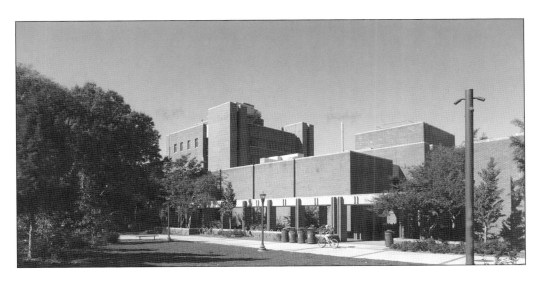

HOWEY PHYSICS BUILDING, 1967 (ABOVE), AND BOGGS CHEMISTRY BUILDING, 1970 (BELOW). The Robert and Company's Howey Physics Building and FABRAP's Boggs Chemistry Building stand solidly on the landscape as Georgia Tech's most weighty piles of Brutalist architecture. Stark and sober and almost windowless, these masonry giants rival even the Wenn Student Center in their stolid forms and uninviting formidable presence. Just as the student center, perched on its motte like a citadel, represents a not very subtle response to the student unrest of the 1960s as experienced on campuses nationwide, so contemporary Howey and Boggs (the latter designed by the same architect as Wenn) appear in their substantial forms to embody the forbidding and consequential curriculum housed within. (Above, RMC; below, GTA.)

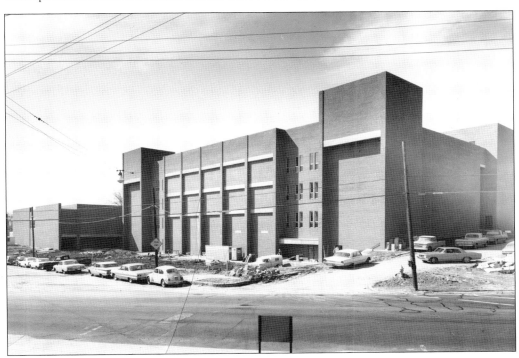

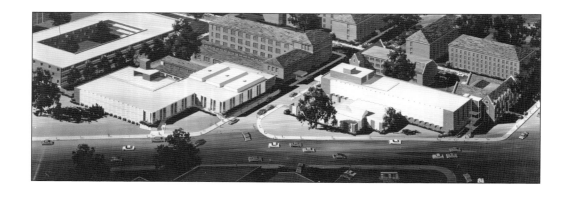

NASA Buildings, 1967–1968. The emergence of the space race after the 1957 launching of Sputnik I and the creation the following year of the National Aeronautics and Space Administration (NASA) ultimately led to the building of Georgia Tech's "NASA Buildings" (the Weber Space Science and Technology Buildings) and the Montgomery Knight Aerospace Engineering Building, both designed by John Cherry. The Knight Building extended northward from the Guggenheim Aeronautics Building and contained labs and an open return low-turbulence wind tunnel. In 2000, Rosser International erected an Aerospace Engineering and Combustion Laboratory on the NARA campus (see page 104). Fourteen Georgia Tech alumni have served as astronauts, including John Young, who was on the first space shuttle and who walked on the moon. (GTA.)

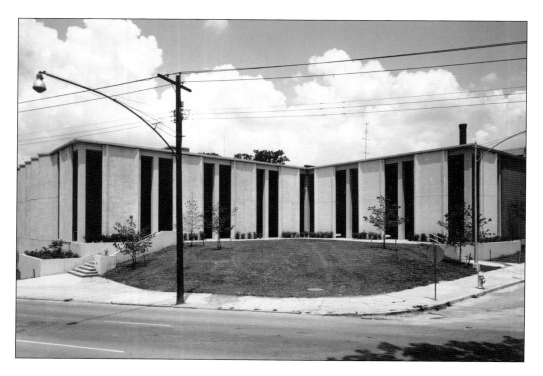

CAMPUS ARCHITECTURE "GOES VERTICAL." As acreage for campus expansion became scarcer, the temptation to "go vertical" increased, and Georgia Tech erected two towers in the late 1960s. Eleven-story Healey Apartments (1970, right, razed) provided student housing at the north edge of campus, and the 1966–1969 Crosland Tower substantially expanded space for the campus library. Originally encased in brick to protect book stacks from harsh sunlight (see page 58 above image), the south and north fronts of Crosland were opened and glazed in the recent remodeling (below) by Kansas City architects BNIM and the local firm of Praxis3, whose founding principal Stuart Romm is a professor of the practice on the faculty of Georgia Tech's College of Design (architecture school). (Right, GTA; below, RMC.)

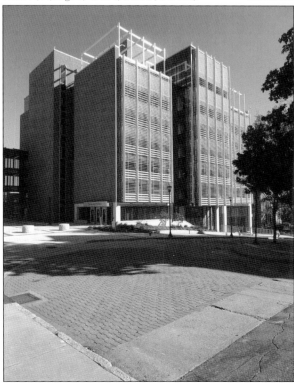

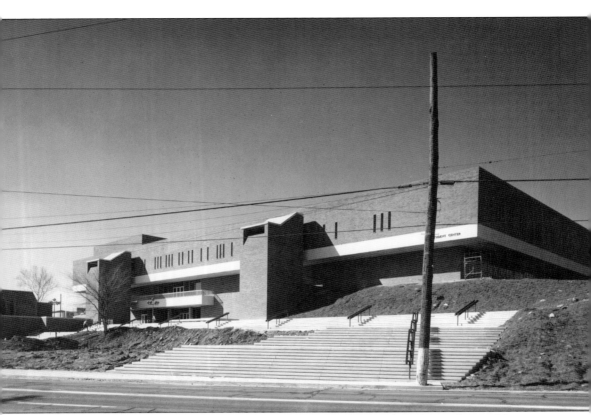

WENN STUDENT CENTER, 1967–1970. The student center was "the subject of more false starts, more frustrations, and more dedicated work by more people than any other building in Tech history," according to *Georgia Tech Alumnus* in 1968. Prof. Fred Wenn, an advisor to the campus chapter of Omicron Delta Kappa, worked with the honors society for some 25 years to raise money for the building. Student enrollment, when the building opened, was about 7,000, and while Georgia Tech's campus had avoided much of the student unrest of the previous decade, the student union still appeared in the form of a bulwark against potential "mob democracy" in the form of student demonstrations against the Vietnam War and for civil rights. The nearly windowless facility contained meeting rooms, dining for students and faculty, as well as some recreational space, including a bowling alley and game rooms. (GTA.)

MASON CIVIL ENGINEERING BUILDING, 1966–1969. Louis Herbert Swayze III studied architecture at Georgia Tech during the closing years of Bush-Brown's directorship, graduating in 1952 when Paul Heffernan taught fifth-year design and structures specialist Herbert "Doc" Gailey was still on the faculty. Swayze's sole campus building, one of the most notable of its period, stands among campus works designed by progressive modernists who are far better known (Paul Heffernan, Robert & Company, and FABRAP). A $12.5 million interior upgrade in 2013 focused on asbestos abatement and HVAC upgrades and provided space for more collaborative student research and team projects through an enhancement of classrooms and teaching labs. The lobby was renovated, a new student commons area and a video conferencing room were created, and new classrooms, offices, and laboratories were provided, including new undergraduate teaching laboratories for Construction Materials and Geotechnical Engineering. The exterior remained as Swayze designed it: a competent sculptural landmark of Brutalist architecture, white and self-assured in its plastic forms and 1960s character, towering against the sky. (GTA.)

AREA III DORMITORY COMPLEX, 1969 (ABOVE), 1972 (BELOW). Traditional red brick continues here with narrow vertical strip openings for stacked, recessed windows projecting from empty surfaces beneath flat-roofed block units. Bradbury's alternative of paired windows at Fitten, Freeman, and Montag varies the rhythm of fenestration, but windows remain otherwise unarticulated as mere wall punctures without sills, lintels, or stringcourses. The west campus residential district has received two highly notable upgrades since the building of these comparatively bland turn-of-the-1970s dormitories: Cooper Carry's Undergraduate Living Center and Eighth/Tenth Street Residences (see page 93) of the Olympics era (along with residential and apartment buildings by Jova Daniels Busby and John Portman (see page 98) and the 2017 West Village Dining Commons (page 111, above image). (Above, GTA; below, RMC.)

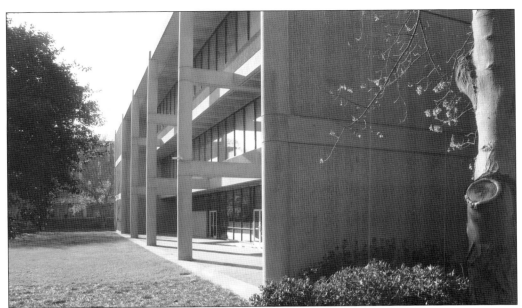

ARCHITECTURE BUILDING WEST WING, 1980.
Throughout the 1960s, New York architect Paul Rudolph adopted an influential aesthetic of dramatic concrete forms and corrugated chipped-concrete surfaces as his personal brand of raw Brutalist architecture, notably evidenced in his 1963 Yale Art and Architecture Building. In the 1970s, such textural surfaces appeared on low-rise office buildings throughout Atlanta's suburban corporate campuses. The chipped concrete surfaces of the West Architecture Building display this influence, while the unfinished concrete staircases are perceived, in the tradition of Le Corbusier's exterior staircase at his Unité d'Habitation in Marseille, to be a piece of heroic form-making in sculpture as much as an element of circulation. (RMC.)

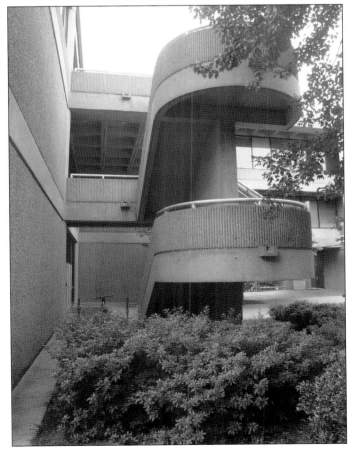

INSIDE THE ARCHITECTURE WEST BUILDING. Like the Brutalists, Tech alumnus Jerry Cooper displayed an interest in naked truth, raw architectural tectonics, and freedom from superficial ornament inside his Architecture Building addition. His building was intended as a teaching aid for architecture students. Structure and mechanical systems are put on open display: free-standing concrete staircases, a hovering coffered concrete ceiling/roof tray, and unenclosed HVAC ducts, piping, and (as technology advanced) data wiring trays and conduits are openly in evidence throughout the interior public spaces. Walls of painted CMU (cinder/concrete blocks) further evidence the direct demonstration of constructional material. Such naked displays of the architectural body's innards recall Alison and Peter Smithson's pioneer Brutalist work at Hunstanton School in Norfolk, England. (RMC.)

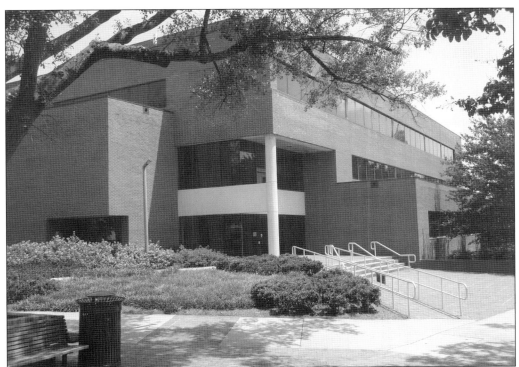

ISyE Complex and Advanced Technology Development Center, 1983–1984. Two building complexes from the mid-1980s harmonize unornamented brick forms in coordinated designs noted for their self-deprecating modesty. The first complex of three buildings is home to the H. Milton Stewart School of Industrial and Systems Engineering (above). The other ensemble, pairing parallel buildings on either side of a linear court, initially housed the Advanced Technology Development Center (Georgia's technology/startups incubator) and is now home to the Georgia Tech Research Institute's Robotics Lab (right). The three ISyE (Industrial and Systems Engineering) buildings, joined by glass-enclosed walkways, comprise the first ensemble of Georgia Tech buildings by architects TVS before Technology Square. The Groseclose Building, named for the "father of ISyE at Georgia Tech," contains four floors of offices for faculty, student labs, and small meeting areas. Most instruction takes place in the Instructional Center, while the annex contains research labs and graduate student spaces. (RMC.)

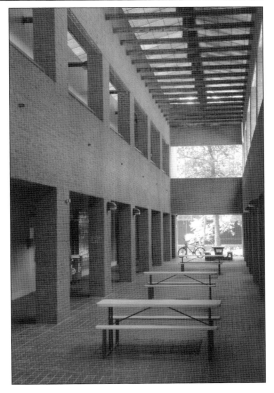

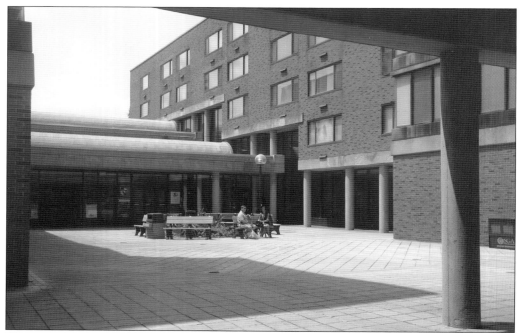

WOODRUFF RESIDENCE HALLS & DINING, 1984–1985. Georgia Tech invested $8.5 million in this suite-style co-ed dormitory (double- and single-bedroom suites with a shared bathroom). The Woodruff dining hall provided food service for the west campus until it closed in 2017 when West Village Dining Commons (see page 111) opened with station-style dining similar to a food court. (RMC.)

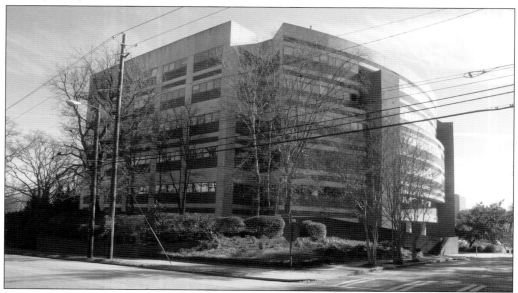

CENTENNIAL RESEARCH BUILDING, 1984–1985. Built on the 100th anniversary of the founding of Georgia Tech, this is a major research building for the Georgia Tech Research Institute (GTRI), Georgia Tech's nonprofit applied research division. Within its six stories are highly specialized electronics research laboratories providing space for high-security research. (RMC.)

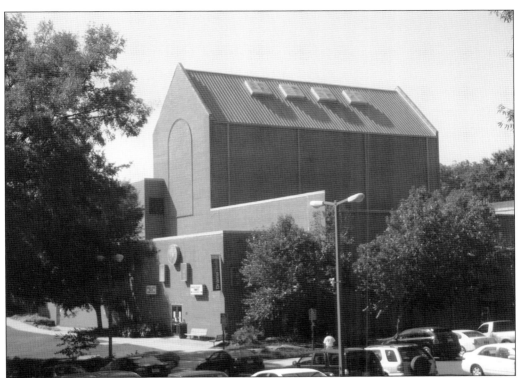

FERST CENTER AND SMITHGALL STUDENT SERVICES, 1989–1992. Although a student troupe known as the Marionettes performed at Georgia Tech between 1913 and World War II, Drama Tech is said to date from 1947 when the Georgia Tech Drama Club was formed, a date making Drama Tech today the oldest continually performing theater in Atlanta. Ferst opened as an expansion of the Wenn student center in an effort to broaden sponsored student campus activities to include live theater, concerts, an art gallery, as well as an improved venue for Drama Tech (now performing in the black-box Dean James Dull Theatre). The same architects that designed Ferst (Johnson Smith Reagan Architects) also developed the Smithgall Student Services addition to Wenn, where an impressive array of flags from the home countries of Tech students adorn an interior gathering space. (RMC.)

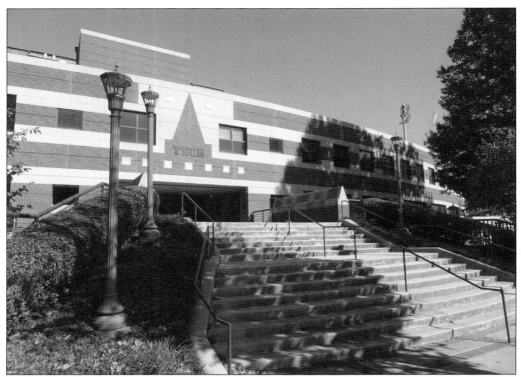

THREE POST-MODERN BUILDINGS, 1986–1989. Three campus buildings by Jova Daniels Busby introduce a new colorism and decorative pattern-making to "Georgia Tech brick" architecture, reflecting currents in Post-Modern design. The Wardlaw Building (1986–1988, above) incorporates in its geometric ornament references to pyramidal Tech Tower. The façade of the College of Computing (1989, below) juxtaposes varying colors of brick to bring ornamental patterns to its entry elevation; within, it provides administrative offices, classrooms, and labs for the new College of Computing, as well as the Institute for Robotics & Intelligent Machines (IRIM). The Petit Building (1989, adjacent to the College of Computing) contains clean room space for the design of devices and circuits in microchip fabrication, enabling the testing of their electronic and optical performance. (RMC.)

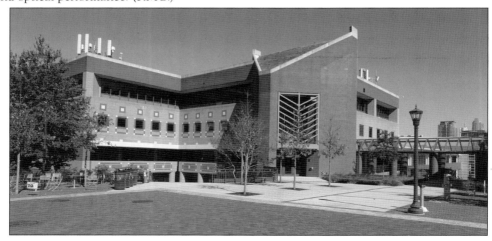

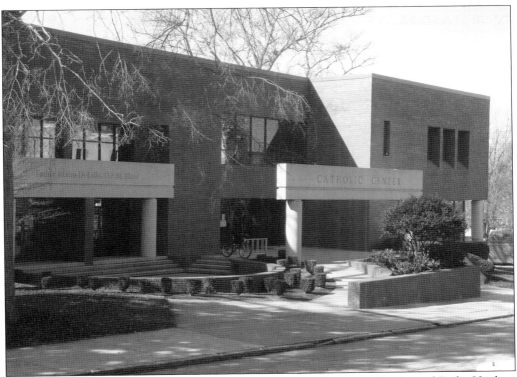

CATHOLIC CENTER, 1983–1985. Georgia Tech faculty members Dale Durfee and Rufus Hughes, in partnership in architectural practice, designed the campus's best landmark of Post-Modern tectonics displaying a richness of materials, natural color perceived almost as ornament, and excellence in efficient, small-scale planning, and contextual siting; the 1983–1985 Catholic Center is sensitively positioned in the fraternity section of campus. (RMC.)

BAPTIST CENTER, DESIGNED IN 1964 AND BUILT 1968–1970. With its concrete surfaces originally left unpainted and raw, the Baptist Center stands as an early exemplar of small-scale Brutalism in which naked materials convey an architectural truth, and tectonic textures and naturalness have value. White paint transformed the building into a Formalist object in the landscape of arguably lesser merit. (RMC.)

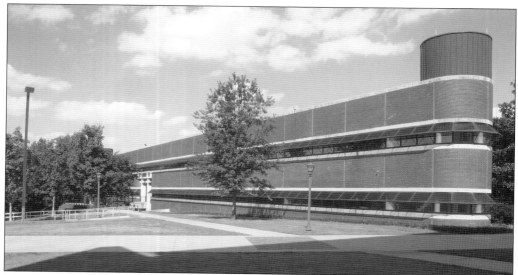

MANUFACTURING RESEARCH CENTER (MARC I), 1988–1989. Even when projected in drawing form, the design of the Manufacturing Research Center was recognized by *Progressive Architecture* magazine as innovative. It was the nature of the projected building to be so since the functions MARC was supposed to accommodate were unknown. It was to be a building for future, and as yet undefined, research. It also looked to the recent past: the building's formal design sources range from Frank Lloyd Wright at Johnson's Wax to the Pompidou Center in Paris, with the latter the inspiration for MARC's exposed and brightly colored supply pipes in the north atrium. (RMC.)

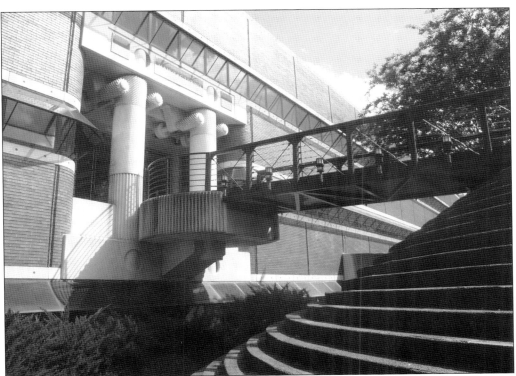

ENTRY, MANUFACTURING RESEARCH CENTER (MARC I). Treating its main entries, front and back, in the tradition of classical *distyle in antis* compositions of the Ionic order, architect Terry Sargent offers here one of the wittiest gestures evident in Georgia Tech's architecture: volutes that are cogs, column fluting that spirals as though turned by the cogs, and ceiling decoration inside that repeats the imagery of interlocking cogs, mechanics, and technology. Although Charles Jencks observed a characteristic of some contemporary architecture to be the communication of "unintended metaphors"—forms recalling objects the architect had not intended as comparisons— here, Sargent has planted his tongue firmly in cheek to declare that his building is purposefully both classic and modern, both industrial/technological and humanist, both reflective of "Georgia Tech brick" traditions, and a foreshadowing of packaging for undefined and as yet un-researched manufacturing. (RMC.)

INSTITUTE OF PAPER SCIENCE & TECHNOLOGY, 1990–1992. Founded in Wisconsin in 1929 as the Institute of Paper Chemistry, the research organization moved to Georgia Tech in 1989 and was renamed the Institute of Paper Science and Technology, now the Renewable Bioproducts Institute. The research includes pulp and paper processes and biomaterials and fuels. There is also a museum of the history of paper in the Robert and Company building. (RMC.)

MOORE STUDENT SUCCESS BUILDING, 1991–1993. Built on the site of Knowles dormitory (razed 1992), the student success building provides space for meetings, conferences/ trade shows, corporate interviews/ recruitment events, receptions and parties, weddings, and other special events. It houses offices for undergraduate admissions, scholarships and financial aid, a career center, and other student services. Many rooms overlook Bobby Dodd Stadium, to which it is attached. (RMC.)

GRADUATE LIVING CENTER, 1991–1993. Both the Graduate Living Center (1993) and architect Niles Bolton's University Village (1996, see page 99), with the latter built for the Olympics and ultimately transferred to Georgia Tech, were early projects of an architectural practice that has found success nationally as designers of student housing. The Graduate Living Center (GLC) replaced Callaway and Healey apartments providing four-bedroom, two-bath apartments with shared living room and kitchen for graduate students. (RMC.)

UNDERGRADUATE LIVING CENTER (ULC), 1993–1994/EIGHTH STREET APARTMENTS, 1994–1995. During the 1990s, a total of 291 housing units were built on campus (more than all previous years combined). Cooper Carry designed large complexes of west campus apartments for undergraduates reflecting the substantial growth in enrollment. ULC (two-, four-, and six-bedroom apartments) was renamed Nelson-Shell Apartments when renovated in 2013; Eighth Street Apartments initially housed athletes and journalists as part of the Olympic Village. (RMC.)

Technology Square, 2001–2003. Technology Square, a multi-building urban complex by tvsdesign sited on 13.5 acres across the freeway from campus, was Georgia Tech's largest capital improvement project to date, costing $256 million. Providing an east gate to campus and significantly engaging Georgia Tech with midtown development, this was president Wayne Clough's crowning achievement. With the subsequent construction of John Portman's CODA, Anthem Technology Center, and the 712 West Peachtree Street office tower (the latter currently under construction to the south), the midtown urban design development continues to expand Atlanta's premiere technology corridor. (RMC.)

Six

ARCHITECTURE DURING G. WAYNE CLOUGH'S PRESIDENCY, 1994–2008

G. Wayne Clough, Georgia Tech's 10th president, stewarded over $1 billion in capital improvements on campus during his 14-year tenure. The projects included west campus dormitories (that temporarily served to house athletes in the Centennial 1996 Olympic Village), a complex of buildings for Manufacturing Research, the Biomedical complex, renovations of the student center and Aquatic Center (the latter expanded to become the Campus Recreation Center), two large buildings for advanced computing (Klaus) and for Nanotechnology Research (Marcus), and an expansion of the Fifth Street bridge over the downtown interstate connector to link Clough's urban design project, Technology Square, to campus; Technology Square's several buildings serve to tie Georgia Tech's campus to midtown Atlanta and opened a new east gate to the campus. Campus architecture also spread its wings westward under Cough forming the North Avenue Research Area (NARA), where several new buildings were completed between 1998 and 2005.

Clough's tenure began at the eve of the 1996 Centennial Olympic Summer Games held in Atlanta. The architecture required for the summer games (when Georgia Tech's campus briefly became the Centennial Olympic Village) and the continuing investments in major new design and construction during Clough's administration brought numerous alumni architects back to Georgia Tech as designers of campus buildings. These included Jerry Cooper (Undergraduate Living Center, 1993–1994, and Eighth and Tenth Street Apartments, 1994–1995); Niles Bolton (University Apartments, 1995–1996); Stanley Daniels and John Busby [Jova, Daniels Busby] (Hemphill Avenue Apartments, 1995–1996); and John Portman (Center Street Dormitories, 1995–1996); these student residence halls initially housed Olympic athletes. In addition, Bill and Ivenue Stanley [Stanley Love-Stanley] did Olympics work (Aquatic Center, 1993–1995 and O'Keefe gymnasium renovation, 1995) and, in 2006–2008, worked with M+W Zander to design the state-of-the-art Marcus Nanotechnology Center. Other alumni contributing to campus architecture during the Cough era include Thomas W. Ventulett III (Technology Square, 2001–2003); Randy Zaic and Michael Hug (fraternity houses for Beta Theta Pi, 1994–1995, and Theta Chi, 2000–2003); Larry Lord [Lord Aeck Sargent] (Student Health Center, 2002–2003); and Janice Wittschiebe of Richards+Wittschiebe (a sorority house for Alpha Xi Delta, 2004, the NARA Structural Engineering & Materials Research Lab, 1998–1999, and the Food Packaging Research Laboratory (with Lord Aeck Sargent, 2004).

Clough also attracted nationally known architects from further afield. Perkins + Will joined local architects Nix Mann in the powerful J. Erskine Love Jr. Manufacturing Building (1997–2000), housing state-of-the-art research facilities in acoustics and dynamics, fluid mechanics, thermal systems, nuclear and radiological engineering, and other areas of inquiry. The J. Erskine Love Building is part of MARC, whose other two buildings (1991 and 1995) were designed by Lord Aeck

Sargent. Perkins + Will then (2002) designed the Christopher W. Klaus Advanced Computing Technology Building, completed in 2005. Between 1998 and 2006, Hellmuth Obata Kassabaum (HOK), the renowned St. Louis firm, designed Georgia Tech's Life Sciences and Engineering Complex to serve new graduate studies and research activities following joint agreements between Emory University's medical school and Georgia Tech's biomedical engineering programs. The building designs sought to enhance interdisciplinary collaborations, and the Ford Motor Company Environmental Science & Technology Building was the campus's largest building when it was completed in 2002. Another St. Louis firm, Hastings + Chivetta Architects, redesigned the campus's Olympics Aquatic Center and developed the Campus Recreation Center that opened in 2004.

Collectively, architectural development under Clough represents a formidable accomplishment that dramatically altered the character and scale of the campus. Research projects, much of which took place in these new buildings, more than doubled in expenditures from $212 million to almost half of $1 billion. Student enrollment jumped from 13,000 to 18,000, and in addition to dramatically expanding graduate and research programs, Clough encouraged undergraduate research and placed a new emphasis on quality education for pre-baccalaureate students. A major project, completed in 2011 after Clough stepped down, was the Undergraduate Learning Commons, the campus's largest building to date, and named for G. Wayne Clough. A model of sustainable design (it was certified at the highest level of Platinum by LEED [Leadership in Energy and Environmental Design]) and an embodiment of Clough's philosophy that undergraduate education is the foundation rock on which advanced research and development are grounded, the Undergraduate Learning Commons appropriately bears the name of Georgia's 10th president who oversaw Georgia Tech's most expansive period of campus development.

The departure of Clough, who became Secretary of the Smithsonian Institute in 2008, together with the recession of 2008, dramatically slowed building projects at Georgia Tech after unprecedented campus development during the previous decade and a half. The new architecture would be forthcoming, but a major contribution of the coming years would be an increased awareness of landscape issues on campus, the development and beautification of campus open spaces, and an increased focus on green architecture and sustainability.

MANUFACTURING RELATED DISCIPLINES COMPLEX I (1995) AND II (ERSKINE LOVE BUILDING, 1997–2000). As Wayne Clough (1964 alumnus) became Georgia Tech's 10th president in September 1994, the Manufacturing Related Disciplines Complex (MRDC), Lord Aeck Sargent's second project for manufacturing research, was under construction, and the third manufacturing edifice, the striking MRDC II building would soon appear to complete the manufacturing research complex. The MRDC I facility includes four non-hierarchical "pods" arranged on either side of an interdisciplinary laboratory spine, the latter accented by exterior brick exhaust shafts. MRDC II (Erskine Love Building) houses the George W. Woodruff School of Mechanical Engineering and includes (along with classrooms and offices) state-of-the-art research facilities in acoustics and dynamics, fluid mechanics, thermal systems, nuclear and radiological engineering, and health/physics and a notable wind tunnel lab and electron microscopy labs. (RMC.)

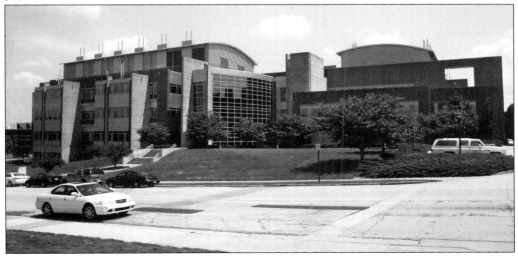

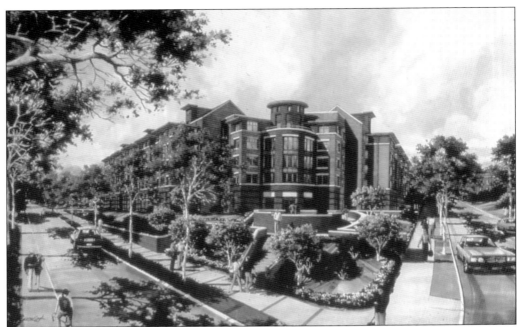

CRECINE (HEMPHILL AVENUE) APARTMENTS, 1995–1996. One of several apartment-styled residence halls, the Hemphill Avenue Apartments housed athletes and journalists when the Georgia Tech campus was fenced off and secured as the Olympic Village for the 1996 summer games. When former Georgia Tech president John Crecine died in 2008, the building was renamed in his honor. (GTA.)

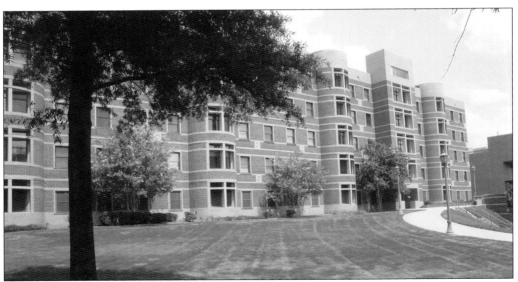

CENTER STREET APARTMENTS, 1995–1996. John Portman's two apartment blocks, known simply as the Center Street Apartments, were also initially built for and utilized by Olympic athletes for the Centennial Olympic Games, and subsequently, 160 students are housed in the north block, with 192 in the southern block. Breaking with the campus's redbrick tradition, the tan tonalities bring a distinctive individuality to the residential complex. (RMC.)

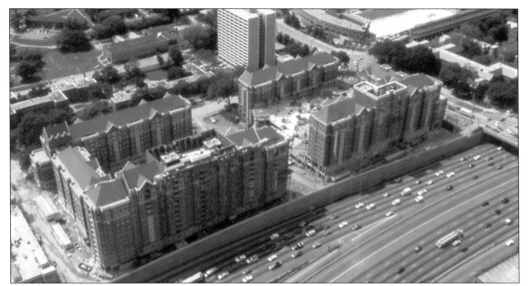

UNIVERSITY (NORTH AVENUE) APARTMENTS, 1995–1996. The four buildings of University Village, built for the Olympics and then utilized by students of Georgia State University, stand on the former site of Techwood Homes and Tech's McDaniel Dormitory. After transfer to Georgia Tech in 2007, it was discovered that during construction, bricks had not been properly secured to the east (freeway) elevation, whose masonry face was removed and re-mortared in place. (GTA.)

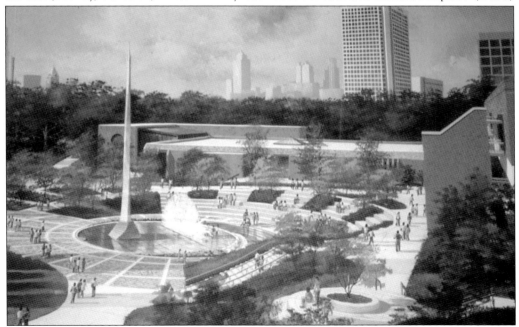

GEORGIA TECH PLAZA/KESSLER CAMPANILE, 1995–1996. The 300-seat amphitheater by EDAW is highlighted by an 80-foot-high twisted and tapering campanile by artist Richard Hill, fabricated of 244 stainless steel plates that rotate up to a pyramidal cap inspired by "Tech Tower." Within are four 150-watt halogen bulbs, whose light is bent by 3,904 glass-rods. The 48-inch-wide base tapers to 18 inches. (GTA.)

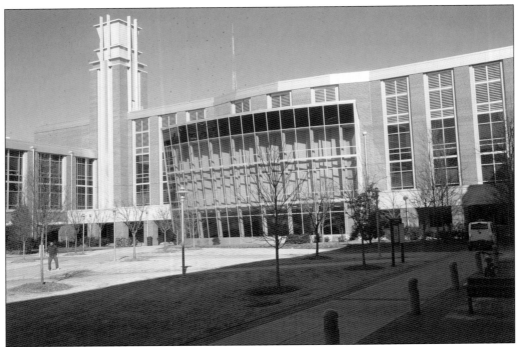

LIFE SCIENCES AND ENGINEERING COMPLEX, 1998–2006. Comprising the Parker H. Petit Institute for Bioengineering and Bioscience (IB2) Building, 1998–1999; the Ford Motor Company Environmental Science & Technology Building, 2002–2003 (above); the U.A. Whitaker Biomedical Engineering Building, 2002–2003; and the Molecular and Materials Science and Engineering Building, 2006 (below), this complex of four buildings provides labs and classrooms to support Georgia Tech's and Emory University's joint PhD degree in biomedical engineering. The Petit Institute is headquarters for biomedical and bioengineering centers that conduct research in pharmaceuticals, cancer, heart disease, and infectious diseases. The $58 million Ford Building, the institute's largest academic building at the time, supports research in environmental science and sustainable technologies. The concrete-framed Whitaker Building contains two wings of classrooms, laboratories, offices, and a state-of-the-art, 75-seat lecture theater, joined by a connector providing space for public gatherings. (RMC.)

TECHNOLOGY SQUARE, 2000–2003 (RIGHT), AND FIFTH STREET BRIDGE, 2004–2006 (BELOW). Architects TVS (now tvsdesign) considered Wayne Clough's Technology Square a "giant leap forward in Georgia Tech's vision of reaching out and connecting to the city and business community." New life was brought to a depressed acreage of midtown by retail shops geared to students and urban residents, and the area became a magnet for technology research and innovation. The architecture is distinguished by large cantilevered lantern-like glass structures at the buildings' corners. The Fifth Street pedestrian bridge (SRSSA, Arcadis US, engineer), Atlanta's first GDOT design-build project, has three traffic lanes, two bike lanes, and a 25-foot-wide sidewalk on each side of the roadway. Stepping up behind the sidewalks are green spaces with planters behind a continuous concrete bench, the whole creating a pedestrian-friendly, park-like corridor and new gate to campus. (RMC.)

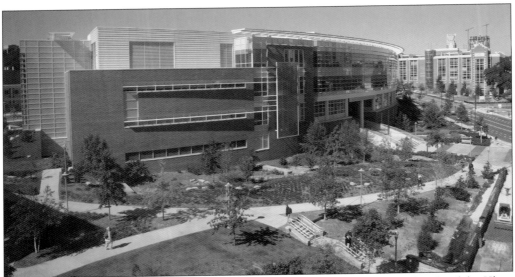

KLAUS ADVANCED COMPUTING BUILDING, 2002–2005. The prominence and scale of the Klaus Advanced Computing Building, with its majestic curved-glass façade terminating the 5th Street vista as it also sweeps along the curve of Ferst Drive, creates a notable campus landmark. The "back side" is no less spectacular as an elegantly detailed bridge connects Klaus to the 1989 College of Computing Building on Atlantic Drive (see page 88) while also framing a landscaped court space as it terminates a north/south campus cross-vista from the Architecture Building and the Clough UG Commons. It is a masterful performance of site planning and architectural design and a creative use of the six-acre footprint enclosing seventy labs, eight computer labs, five distant learning classrooms, a 200-seat auditorium, and a three-story, 550-car, parking garage beneath while preserving over half the site as green space. (RMC.)

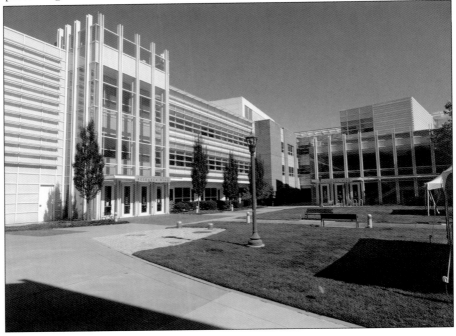

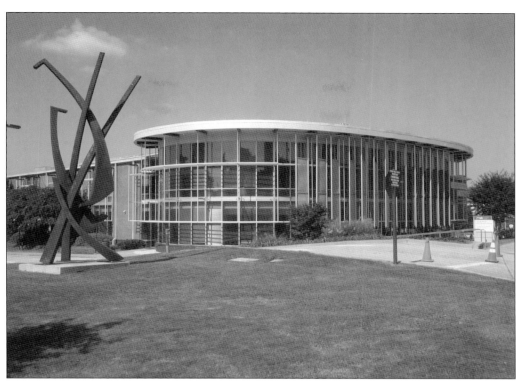

WHITEHEAD/STAMPS STUDENT HEALTH CENTER, 2002–2003. The student health center, historically the third infirmary on campus, is an outpatient ambulatory center, including a medical clinic with examination rooms, a dental clinic, a women's center, X-ray facilities, and a wellness center. Services include primary care, women's health, psychiatry, health promotion, and support services of pharmacy, laboratory, and radiology. Physicians and nurses experienced in the care of college-aged students are skilled in the areas of general medicine, travel medicine, acute injuries or illnesses, allergy management, and immunizations. The building features a gently curving glass facade with gossamer banner sun screens held in place by tension cables secured to truncated conical posts, bringing a tautness to the expressive east façade. The rectangular building behind is glazed without screens on the north and mostly brick on the south. (RMC.)

NORTH AVENUE RESEARCH AREA, 1993–2012. At NARA's laboratories, researchers test the strength of building materials and viability of designed structural systems, study heat and mass transfer processes to improve sustainability in design, and analyze combustion applications (from rockets, airplanes, and cars to lawn mowers) in search of cleaner fuels and combustions processes. Research in food quality and safety, from processing to marketing, serves the state's poultry and agriculture industries. NARA includes the Tech Way Building, 1970 (occupied 1993), renovated 2009; the Structural Engineering & Materials Research Lab, Richards + Wittschebe, 1998–1999; the Zinn Aerospace Combustion Laboratory, Rosser International, 2000; the Food Packaging Research Laboratory, Richards + Wittschiebe/Lord Aeck Sargent, 2004–2005 (above); and the Carbon Neutral Energy Solutions Laboratory, HDR-CUH2A (headquartered Princeton, New Jersey, a design/build project), Gilbane Building Co., 2011–2012 (below). The 2006 Strong Street Gatehouse (above) is by plexus r+d. (RMC.)

MARCUS NANOTECHNOLOGY RESEARCH CENTER, 2006–2009. Marcus Center scientists conduct research in microelectronics, medicine and pharmaceuticals, nanoscience, and nanotechnology. Behind the perforated copper façade at the building's west end (an elevation resembling a circuit board) is the clean room block for both bio-nanotechnology (20,000 square feet) and physio-nanotechnology (10,000 square feet), supporting both organic and inorganic nanotechnology research. Laboratories, offices, and conference rooms fill the east block, with its transparent glass curtain wall shaded by sun screens and a high slab canopy. In between is the building entry and atrium "linchpin," a connecting galleria full of light and containing within its more public space a steel and glass stairwell within a distinctive oval cylinder. The architects were M.W. Zander (now M+W Group, of Stuttgart, Germany), Bohlin Cywinski Jackson (Philadelphia), and Stanley Love-Stanley Associates (Atlanta). (RMC.)

CLOUGH UNDERGRADUATE LEARNING COMMONS, 2002–2011. Clough Commons is the campus's signature building of recent years. Bearing the name of Tech's president emeritus, the building reflects Clough's intentions, at an increasingly research-oriented institution of graduate studies, to advance Georgia Tech's undergraduate education, a goal reflected in the many student support facilities within. Mandates for energy conservation resulted in the building's LEED Platinum certification, the highest LEED designation of sustainability achievement. The green roof instantly became a favorite student garden space. The open landscape that fronts the "smart building" incorporates a 1.4 million-gallon cistern to collect stormwater from the site. Heffernan's Textile Engineering Building once stood here, and its regrettable loss is compensated for, in part, by the creation here of a new campus center, a crossroads, and open landscape enhanced by one of the school's most-admirable buildings. (RMC.)

Seven

CONTEMPORARY ARCHITECTURE, 2008–PRESENT

Georgia Tech's campus architecture after Wayne Clough has not been extensive, but developments on campus in the landscape, the introduction of more art in open spaces, and a continuing focus on sustainable design have been noteworthy. The new campus green, between the Wenn student union and the 2010–2011 Clough Undergraduate Learning Commons, is a major open landscape and something of a collegiate crossroads; as a new campus center, it complements the original campus historic district, with its focal landmark building, Tech Tower, overlooking the campus's original open green. A second campus urban center at Technology Center, built under Clough, continues to expand with John Portman's recent 21-story, 664,752-square-foot Coda Tech Square (2019), followed by his Anthem at Tech Square, 2019–2020, and its "sibling," the 712 West Peachtree Building begun this year. Although not strictly "on campus," Coda Tech Square hosts Georgia Tech as its principal tenant and continues Technology Square's role as an "innovation hotbed," with corporations interacting with researchers, faculty, and students, and with incubators generating technology startups, which has been a goal of Georgia Tech's research arm since the inception of the Georgia Research Institute almost a century ago (1934).

The administration of Georgia Tech president Bud Peterson began with the 2008 recession, a crisis affecting world financial markets, banking institutions, and the real estate market, and resulting in the longest period of economic decline since the Great Depression of the 1930s. Campus building came to an abrupt halt and did not really recover for five or six years. The John and Joyce Caddell Building, which opened in 2015, was a small restart to renewed campus architectural development. Georgia Tech alums David Yocum and Brian Bell of BLDGS completely remodeled a 1950s concrete and steel garage building inside and out, providing 10,600 square feet of flexible teaching areas, faculty offices, and collaborative spaces. The goal was a building that "excels in collaboration, sustainability, and technology" while making an architectural statement on campus as the home for the building construction program, a part of the College of Design. It was a small but effective new beginning for campus architecture.

Collaboration between Emory and Georgia Tech in bio-med research and technology culminated in the design by Cooper Carey (with Lake|Flato Architects, Associate Architect) for the Krone Engineered Biosystems Building (EBB), which also opened in 2015. The building provides 220,000 square feet of multidisciplinary research space and houses labs for research in chemical biology, cell and developmental biology, and systems biology in a design that was certified LEED Platinum.

The campus's major work of sustainability, surpassing even the LEED Platinum certification of recent buildings on campus, is Georgia Tech's Kendeda Building for Innovative Sustainable Design, 2017–2019, a 42,000-square-foot education and research facility designed with an eye to becoming a model building in the southeast in the Living Building certification program, the

toughest environmental accreditation on the market. Living Building certification demands that all energy be produced on-site and that the architecture surpass the net-zero standard of energy consumption and actually be restorative (net-positive energy and net-positive water, meaning that the architecture is built of recycled materials, improves the availability of energy, enhances water quality, and removes waste from the environment). Certification is not based on design and projections but actual performance over a year. As of the date of this writing, the Kendeda Building for Innovative Sustainable Design's performance in these various dimensions of sustainability is being measured against the most demanding standard of any building on campus, indeed, anywhere in the southeast region.

Georgia Tech campus architecture continues to balance an array of difficult issues. Occupying an urban campus of limited acreage, Georgia Tech planners have continued to enhance the campus environment with improvements in architectural design, open space, and campus walks. As a leading research institute engaged in innovative advances in science and technology, Tech asks architects to design buildings for the future that can accommodate as yet unknown research agendas and inquiries. As was projected for the Manufacturing Research Building over 30 years ago, an institute of technology's campus architecture must provide for functions as yet unknown, for research in fields yet to be developed, and for students and faculty needs both now and in the future.

Similarly, as an institute of technology, Georgia Tech accepts its role as a leader in sustainable design. Fifty years ago, George Ramsey of the architecture faculty encouraged a greater awareness of passive solar energy in design strategies bringing focus to daylighting, to building orientation, and to minimizing energy consumption through strategic architectural design. The Leadership in Energy and Environmental Design program (LEED) developed by the US Green Building Council encourages environmental responsibility in the design, construction, operation, and maintenance of green buildings. Initiated in 1993, the LEED program today boasts over 83,000 registered and certified LEED projects worldwide. Georgia Tech set a goal that all its new construction would target LEED Gold and, more recently, seeks LEED Platinum, the highest level. The Living Building project raises the bar even higher, demanding that architecture produce more energy than it uses. Campus architecture would thus become a model for builders and consumers worldwide, a role Georgia Tech purposefully positions itself to play as a technology leader.

CLOUGH UNDERGRADUATE LEARNING COMMONS STAIRCASE. The staircase in the Clough Undergraduate Learning Commons (ULC) has become a student gathering spot for lounging, conversation, and reading. The feature is more than a vertical circulation device but encourages socialization and enhances the aesthetically pleasing character of the interior architecture. Martin Dawe's 2019 bronze sculpture *The First Graduate* is exhibited here, depicting Ronald Yancey (EE 1965), the first African American to graduate from Georgia Tech. (RMC.)

CLOUGH ULC ROOF GARDEN. More than half of the roof is green, featuring an 18,000 square-foot garden offering skyline views of the surrounding campus and city. Horticulturalists planted 39 native species, especially those requiring less watering and thought to be self-sufficient in this climate within a few years. Sustainability efforts also included sensitive hardscape design (such as paving), the use of local materials, and steps to filter rainwater runoff. (RMC.)

CADDELL BUILDING, 2015.
Housing the School of Building Construction, Caddell was mandated to excel in collaboration, sustainability, and technology and to make an architectural statement. Caddell's interior is a test site for "flex space" classrooms and variable, open-format learning spaces. The exterior solar shading canopy, cantilevered on all four sides of the structure, projects 28 feet beyond the east façade. The architects were David Yocum and Brian Bell (BLDGS). (RMC.)

KRONE ENGINEERED BIOSYSTEMS BUILDING, 2015. EBB continues Georgia Tech's encouragement of interdisciplinary interaction among researchers in buildings specifically designed to accommodate collaborative research. In this first building of Tech's planned research quad, EBB fosters interaction among faculty and researchers from the colleges of engineering and science focused on chemical biology, cell biology, or systems biology. (RMC.)

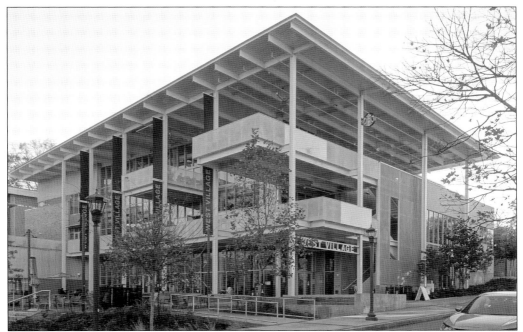

WEST VILLAGE DINING COMMONS, 2017. Architects Cooper Carry (associated here with Lake|Flato and Koons Environmental Design) considered the commons a multipurpose living room for west campus, a much-needed gathering place for students, residents, and visitors. Intended to support "the whole person with respect to social connection," facilities include flexible open-plan dining, outdoor spaces providing connections to nature, rehearsal and conference rooms, and places "for quiet moments of reflection." (RMC.)

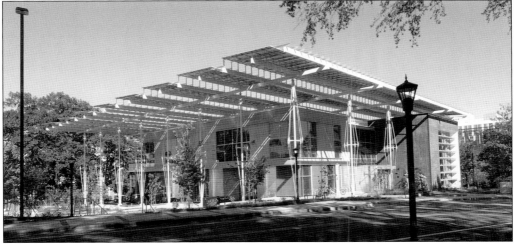

KENDEDA "LIVING" BUILDING, 2017–2019. The Kendeda Building for Innovative Sustainable Design seeks Living Building Challenge (LBC) certification (currently pending), the world's most rigorous sustainable design and performance standard for buildings. A "Living Building" must produce more electricity than it uses on-site through renewable sources, as well as collect, treat, and reuse annually more water than it needs. Architects were Lord Aeck Sargent and Miller Hull Partnership (Seattle). (RMC.)

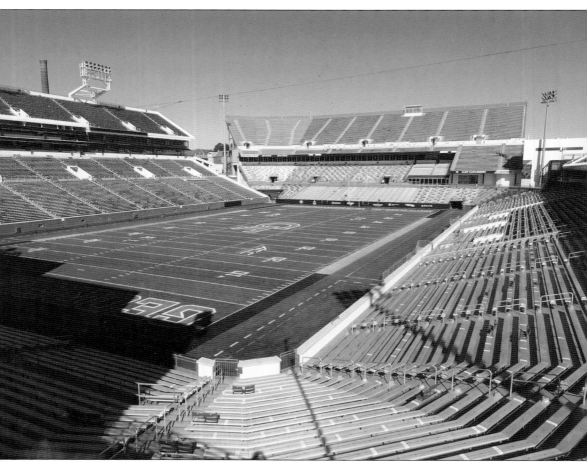

Bobby Dodd Stadium, 1924–1925 and After (View Looking North). Now the nation's oldest Division I-A on-campus stadium, the stadium began with grandstands erected in 1914–1915 overlooking the Flats. In 1924–1925, Robert and Company built new east and west stands, including a concrete arcade along Techwood Drive, referenced today at the Beech Family Gate 9. Structural engineer J.J. Pollard, working with associated architect Richard Aeck, cantilevered new stands and a press box on the west side in 1947, bringing the seating capacity to 40,000. Contractor J.A. Jones added steel stands to the north end in 1958–1959, and in 1961–1962, a second deck appeared on the east side, bringing the seating capacity to 53,300. FABRAP's upper deck on the west side allowed for the highest capacity at almost 60,000. The Wardlaw Building eliminated seating for 12,000, and HOK replaced some lost capacity at the south and east sides, reconfigured the playing field, and added the dramatically cantilevered north end zone structure in 2003. (RMC.)

Eight

ARCHITECTURE OF ATHLETICS

The architecture of play is a unique manifestation of functional architecture. The modern playing field and football stadium find their roots in ancient Greek competition sites such as the running field at Olympia or the gymnasium at Delphi, and in Roman stadium structures such as the *Kallimarmaro* Roman (Panathenaic) Stadium in Athens, the Colosseum in Rome, or the Roman arena rising above the houses of Nîmes in France. Even as far afield as Plovdiv, Bulgaria, the Romans built a stadium that could seat 30,000 spectators. The difference in scale between surrounding houses and shops and such megastructures in the ancient city was as stark a contrast as may be drawn in comparing the Flats at Georgia Tech surrounded by single-story wood-frame houses with the campus's Bobby Dodd Stadium today, with its rising cantilevered stands and current seating capacity of over 55,000.

The campus's architecture for athletics includes most dominant on the landscape, this megastructure for football, the modern deity as powerful a draw to the holy site on a fall weekend as Zeus was to Delphi. Third Street behind the north stands used to be lined with the Navy Armory (1934), the Heisman Gymnasium (1934–1936) and Swimming Pool (1939), and the Athletic Association Building (One Ninety Building, 1941), a collection of Modern Classic buildings whose construction was aided by New Deal programs such as the WPA. The Heisman Gymnasium was especially noteworthy with its 1934 design by Robert and Company reworked by Matt L. Jorgensen of Bush-Brown and Gailey and built in 1935–1936; the auditorium-gymnasium's exterior was inspired by Paul Cret's 1932 Folger Shakespeare Library in Washington, DC.

At the edge of campus, one of the city's 1920s Romanesque Revival public schools dominated the landscape, Daniel O'Keefe Junior High School. Designed by Marye, Alger, and Alger and built in 1922–1924, the school was expanded several times with an auditorium and classroom wing added by G Lloyd Preacher in 1928–1929; a gymnasium built by J.W. Kreis in 1945; and a second gym, military, and physical education addition in 1949–1950 by Bodin and Lamberson; and additional classrooms added by Albert O. Ordway in 1964–1965. The school was closed in 1973 and acquired by Georgia Tech soon thereafter, and in 1995, the 1949–1950 Bodin and Lamberson gymnasium was restored to serve as the home of the Yellow Jackets volleyball team. In 2009, the Shirley Clements Mewborn Field was dedicated to women's softball, adjacent to the west side of O'Keefe. Mewborn was one of the first two women to receive a degree from Georgia Tech, a bachelor of science in electrical engineering in 1956.

Extending north between Fifth and Tenth Streets, a baseball field, track and field grounds, and tennis facility are sites calling for basic sports facilities such as bleachers and stands but no distinguished architecture. The indoor football and tennis facilities are especially mundane in their boxy forms with segmental-arched roofs, as inelegant as a Quonset hut. However, the dominant work of architecture for athletics in this part of campus is the William A. Alexander Memorial Coliseum, or "thriller dome," originally a structurally expressive building (270 feet diameter) by Richard Aeck, completed in 1956 and thus roughly contemporary with Pier Luigi Nervi's famous 1956–1957 Palazzetto dello Sport (200-foot diameter) for the 1960 Rome Olympics. When first

built, the highly visible exterior of Aeck's dome brought a futuristic character to the coliseum. Inside, the ribs are exposed in a structurally expressive design that gives the roof the appearance of floating weightlessly above a vast circular arena. Recently, the building was wrapped in a less exciting architectural envelope when the coliseum was enlarged in 2010 and renamed McCamish Pavilion. The $45 million renovation included a reconstruction of the seating bowl, an addition of an upper-level balcony and club seating, and an expansion of the concourse and plaza area.

The other major landmark of campus athletic architecture is the Aquatic Swimming Pool built for the 1996 Centennial Olympics and redesigned and expanded in 2001–2004 by the St. Louis architectural firm, Hastings + Chivetta Architects, Inc. to become the Campus Recreation Center (SAC II). The remodel involved enclosing the Olympic Aquatic Center's pool and diving well and constructing a full-scale gymnasium above the pool but under its original roof. The new complex includes six basketball courts, weight and aerobics rooms, a leisure pool, racquetball courts, squash courts, an auxiliary gymnasium, lounge, parking deck, and an elevated jogging track offering views of the skyline of Midtown Atlanta.

One should not forget the more informal athletic venues on campus, for which buildings are not erected nor roads marked, yet tradition abounds: the Tyler Brown Pi Mile Trail (a 3.14-mile course named for a former student government president killed in action in Iraq in 2004), or the Dean George C. Griffin Pi Mile Race Course (a 5K race, named for the former student dean, that has weaved its way through campus since 1972), or the Ramblin' Wreck Homecoming Parade route. George P. Burdell sightings are sometimes reported.

West Stands, Dodd Stadium, 1947. At both Grady High School stadium (1947–1949) and Grant Field (1947, renamed Bobby Dodd Stadium in 1988), architect Richard Aeck's firm displayed innovations in structural engineering, working with Bush-Brown, Gailey, and Heffernan on the new west stands. The breathtaking forms, hovering over Knowles Dormitory (later replaced by the Bill Moore Student Success Building), still exhibit their remarkable feat of postwar engineering today. (GTA.)

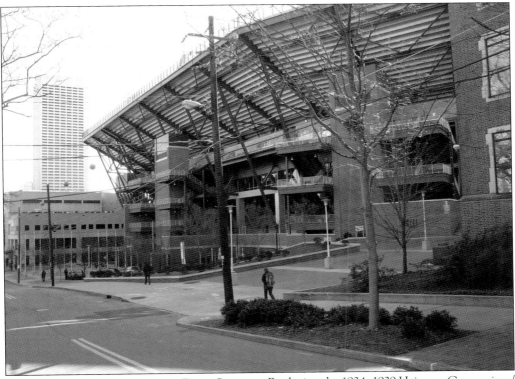

North Stands/Callaway Plaza Dodd Stadium. Replacing the 1934–1939 Heisman Gymnasium/Pool and the 1941 Athletics Building (see pages 116–117), Callaway Plaza was tucked under HOK Sport's hovering north stands. The plaza contains statues of both John Heisman (1988) and Bobby Dodd (2012), two of Georgia Tech football's most successful coaches. The Heisman Trophy, awarded annually to the best (NCAA) college football player, usually a running back or quarterback, honors John Heisman. (RMC.)

NAVAL ARMORY, 1934–1935 (ABOVE), AND ATHLETIC ASSOCIATION BUILDING, 1941 (BELOW), (BOTH RAZED). In 1926, the Navy Department authorized the establishment of ROTC (Reserve Officer Training Corps) units at six colleges, including Georgia Tech. Built partly with student labor, the Naval Armory was characterized by crudely finished exterior surfaces with sculptural enrichments by Julian Harris, including a bronze gate (extant). Completed in 1935, the facility included an elaborate ship's bridge with a complete communications system, an operational ship's boiler, a lifeboat with davits, a signal flag bag, and signal lights. Since its founding, the unit has commissioned over 3,000 officers. With the Heisman Gymnasium/Auditorium (page 117) and Athletic Building aligned to the west of the Armory, the streetscape was one of the city's most notable Modern Classic ensembles of New Deal architecture. All three buildings have been razed. (GTA.)

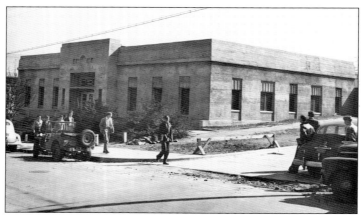

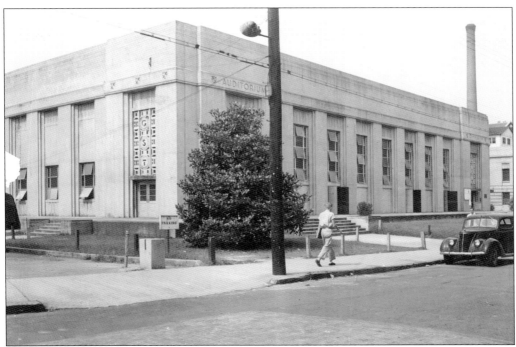

AUDITORIUM GYMNASIUM AND POOL, 1936–1939 (ABOVE), (RAZED); AND ARTHUR B. EDGE INTERCOLLEGIATE ATHLETIC CENTER, 1982 (BELOW). The Heisman Gymnasium (1935–1936) was the first reinforced concrete structure on campus. Surfaced in Georgia marble quarried in Tate, Georgia, the gymnasium was partially funded by the PWA. Bush-Brown and Gailey also designed the swimming pool addition of 1938–1939, constructed behind the gymnasium with both WPA and PWA funds. Later, utilizing a Brutalist concrete aesthetic formed in the image of cyclopean blocks, Robert and Company's Edge Center prompted the razing of the Armory, and in anticipation of the expansion of the north stands and creation of Callaway Plaza, the Heisman Gym, Pool, and 1941 Athletic Building were demolished. Ironically when the 2018 renovation of the locker rooms under the north stands began, the 79-year-old, 25-yard Heisman Natatorium was discovered still underground. (Above, GTA; below, RMC.)

ALEXANDER MEMORIAL COLISEUM, 1951–1956. Eleven months after the coliseum opened in 1956, the Russians launched Sputnik I, and this unique campus arena might well have prompted a returning alumnus to believe a flying saucer had landed at Georgia Tech. The coliseum's 270-foot diameter dome provided an arena without support pillars providing an uninterrupted view for just under 7,000 spectators, an architectural, as well as sports, "Thrillerdome," as a sports broadcaster later dubbed it. Renovated by SRSSA (Smallwood, Reynolds, Stewart, Stewart, and Associates) in 1995–1996, the floor was lowered, and additional seats and suites were added to increase the capacity to 9,191. The final redesign to create the McCamish Pavilion was major, although the original dome's exposed interior steel ribs, thankfully, remain. (GTA.)

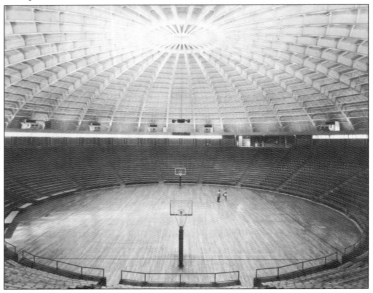

McCamish Pavilion, 2010–2012. The redesign by architects Populous of the Alexander Coliseum, creating the McCamish Pavilion, significantly altered an iconic campus building. The sports arena's interior seating bowl was reconstructed, an upper balcony and club seating were added, and the expansion of the concourse and plaza area substantially altered the exterior forms. The futurist dome from the space age was left straining to peek over the new building forms. (RMC.)

Callaway Student Athletic Center (SAC), 1976–1977. Following a late-1960s study of athletic complexes in the southeast, Georgia Tech's deficiencies in physical training facilities and its lack of variety and flexibility in providing for intramural sports prompted the building in 1976–1977 of the Student Athletic Center (razed) as well as tennis and basketball courts near dormitories and in Peters Park. (GTA.)

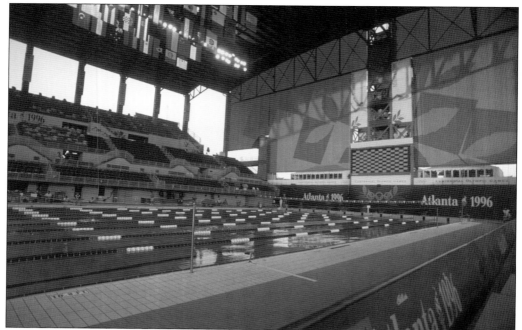

AQUATIC CENTER, 1993–1995 (ABOVE; PRE-OLYMPICS) AND 2001–2004 (BELOW; POST-OLYMPICS).
Replacing the Callaway Student Athletic Center (SAC), the first Aquatic Center was a large open-sided pavilion erected as the swimming and diving venue for the 1996 Olympics. The original roof featured an array of solar panels to ease the electrical burden of the facility. Subsequently enclosed and remodeled by Hastings + Chivetta Architects, the pool's ceiling was lowered with huge girders supporting basketball courts above. The expanded Campus Recreation Center (2004; see page 121) features a full complement of athletic spaces and functions. (Above, GTA; below, RMC.)

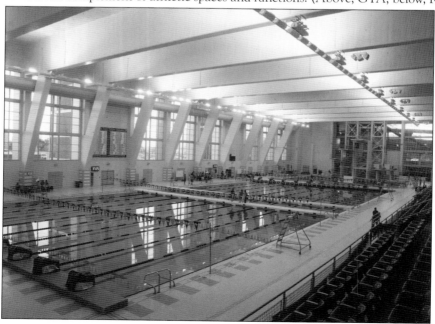

CAMPUS RECREATION CENTER (SAC II), 2001–2004. Five years after the Olympics, St. Louis architects Hastings + Chivetta enclosed the Olympic Aquatic Center's pool and diving well and constructed a full-scale gymnasium over the pool, with six basketball courts, weight and aerobics rooms, and an elevated jogging track. The remodeling was described by the campus news center as a "modern engineering marvel of construction." Phase two of the new recreation center provided a leisure pool, racquetball courts, squash courts, auxiliary gym, lounge, and $4.5 million parking deck. When students returned to campus in the fall of 2003, one-sixth of the campus's architecture was new, and Georgia Tech boasted the completion of $500 million in new constructions and building renovations, more than any other university in the United States. (RMC.)

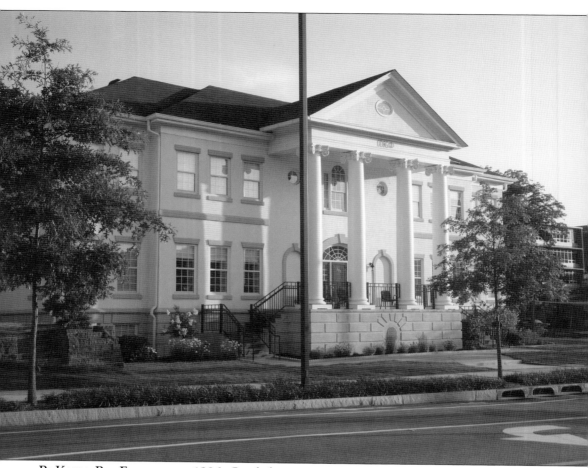

Pi Kappa Phi Fraternity, 1996. Greek fraternities nationwide have adopted Greek Revival architecture for their residences, planting classical porticos and temple forms on campuses across the country. Tech alumnus Bill Harrison has promoted traditional and especially classical design throughout his career and, here, displays a sensitivity to proportion and scale in, perhaps, the best fraternity house design in the classical idiom on campus. Built in time for the 1996 Olympics, the new residence replaced a 1967–1968 house by Gregson and Associates. Unlike some other "frat houses" on campuses, here and elsewhere, in which obligatory columns, piers, or pilasters are affixed to facades in order to render them "Greek," or pretentious porticos, Jeffersonian tetra-style porches, or entry rotundas are pasted on building elevations more as symbolic veneer than coordinated design, there is, in contrast here, an air of correctness to Harrison's design for Pi Kappa Phi, recalling stately homes of the gentry of past eras. Such work parallels Harrison's sponsorship of a visiting scholar program at Georgia Tech and stands as an embodiment of Harrison's life-long advocacy of classical architecture. (RMC.)

Nine

FRATERNITIES AND SORORITIES

Georgia Tech's campus architecture includes over three dozen chapter houses for fraternities and sororities, reflecting an unusually active Greek life on campus. There are 56 Greek chapters, the majority of which occupy 39 houses, mostly relatively newly built as the social organizations have grown and undergraduate student populations increase; it is estimated that 25 percent of Tech students participate in a fraternity or sorority, compared to 9 percent on average nationally.

Georgia Tech alumnus Michael Hug has become a nationally recognized expert in fraternity and sorority design as recognized by the 2018 acquisition of his firm by the Kansas City practice TreanorHL, whose Greek Life Studio has been engaged on over 125 sorority and fraternity housing projects, including master planning, facility assessments, complex occupied renovations, additions, and newly built projects. Hug began his career with Randy Zaic and Associates, who had designed Georgia Tech's Beta Theta Pi fraternity house, inspired by and replacing John Llewellyn Skinner's 1925–1926 fraternity house. Skinner's fraternity residence was built with a prominent colossal portico; the new 1994–1995 Beta house reflected this façade elevation in a colossal-columned loggia recessed between flanking front-gabled double-height bays in a historically sensitive design that won an Atlanta Urban Design Award.

At Georgia Tech, Hug went on to design the Theta Chi fraternity house in 2000–2003 (Zaic Hug and Associates), and, after Hug went out on his own, the Kappa Sigma fraternity house in 2013, the Alpha Phi Sorority in 2017, and the Delta Sigma Phi fraternity in 2018; after his merger with TreanorHL, he designed the Kappa Alpha Theta sorority. These houses are typically stylistic variations on the theme of Georgia Tech's brick "Collegiate Gothic," evidenced since 1922 in neo-medieval classroom and dormitory buildings.

The National Register–listed Chi Phi fraternity house of 1928–1929, Pringle and Smith's Chi Psi (now Alpha Tau Omega) fraternity house of 1929, and Edgar Morris's Delta Tau Delta fraternity house of 1939 are earlier examples of this English house tradition. Gene Surber's Phi Kappa Tau (2009) is a more recent example. But Michael Hug has dominated this niche of residential architecture for campus social fraternities, accommodating the decades-long tradition of the architecture of "Georgia Tech brick" on the Atlanta campus. Equally reflective of traditions in other locales, Hug has provided an accommodating classical language for the Greek houses he has built on other college campuses throughout the region.

At Georgia Tech, one of the most carefully observed and well-proportioned recent fraternity houses in the neoclassical style is the Pi Kappa Phi fraternity house of 1995, a stately residence in the tradition of Anglo-Palladian Georgian houses and the work of another Georgia Tech architecture alum, Bill Harrison. Classical porticos of various sizes and shapes had been attached as entry porches to such Tech fraternity houses as those built for Sigma Alpha Epsilon (1940–1941, Ivey and Crook), Sigma Chi (1995–196, Peter Hand), Lambda Chi Alpha (2005, Richard Wittschiebe Hand), and Kappa Alpha (2001–2003). But none have the authority, correctness, and historicist presence and propriety of Pi Kappa Phi's design.

The social houses collectively present an interesting contrast with campus architecture in general, although, across campus, traditional "Georgia Tech red brick" prevails. While it is said that Atlantans are willing to work in a modern building, they typically prefer traditionally styled architecture for their homes. As Georgia Tech's classroom buildings, laboratories, and research architecture look to modern forms of glass and steel, although frequently turning to red brick for exterior cladding, Greek fraternity and sorority houses, on the other hand, are more conservative and inclined to display their Greek-ness and homeyness on their sleeves: columns and porticos abound, gables, brick residential forms with white porches communicate a sense of home, and casement and double-hung mullioned windows reflect a familiarity with traditionalism that appears to reject any modern industrial or technological aesthetic for campus fraternity houses and sorority residence halls. Indeed, one sorority house (Alpha Gamma Delta) so loved the idea of a broad, frontal, Southern verandah that it stacked three full-width porches atop one another overlooking Fifth Street.

On the other hand, postwar Midcentury Modernism initially informed the progressive designs of some postwar fraternity houses just as it was reflected in 1940s campus housing (such as the 1947 Callaway and Burge Apartments or even later at Hopkins Hall in the Area II dormitory complex). Modern leanings were evident as a counterpoint to classical Greek housing at Sigma Nu in 1951 (Arco Builders), at Kappa Sigma (1951–1952 by Bodin and Lamberson), at John Cherry's 1954 Delta Sigma Phi, and at Wilner and Millkey's 1955 Alpha Epsilon Pi. Local campus architect David Savini, with William Tapp and Andrew Mangione, built Lambda Chi Alpha in 1959–1960, featuring a perforated tile wall influenced by the Midcentury Modern work of Edward Durrell Stone, a feature preserved in the recent reimagining of the house. Finally, Gregson and Associates designed Pi Kappa Phi in 1967, later occupied by Psi Upsilon. However, with their flat roofs, industrial windows, and something of a motel or small factory aesthetic, one by one, the few Modern fraternity houses at Georgia Tech have been replaced by more conservative and presumed homier architecture with columned or porticoed entries, gables and tall chimneys, and traditional building materials in a more historicist language.

There is an irony to this return to tradition by normally more rebellious youth. If the inhabitants of campus fraternity houses are of the age to demonstrate in the street for causes both noble and not, then one wonders why a more adventuresome student group contemplating a new fraternity house has not hired a firm such as Mack Scogin Merrill Elam Architects to give their fraternity house some pizzazz. At the least, such a commission would right an egregious wrong in the architectural history of Georgia Tech—that these internationally renowned architects—Georgia Tech alums, moreover---have never been given a campus commission at their alma mater.

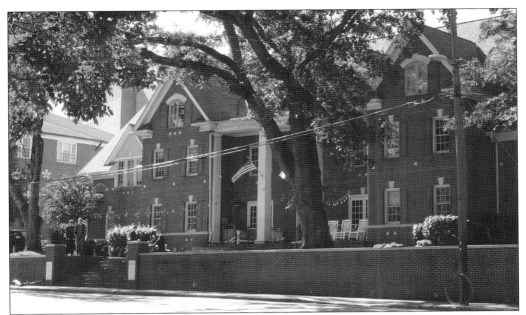

BETA THETA PI FRATERNITY, 1994–1995. Randy Zaic's Beta house design both replaced and was inspired (in its east front forms) by John Skinner's 1925–1926 Beta house. Michael Hug had joined the firm by the time of construction drawings, and the finished building helped launch his career as a specialist in fraternity-house and other residential design. The Zaic/Hug and Associates partnership ended in 2005, with both continuing fraternity work independently. (RMC.)

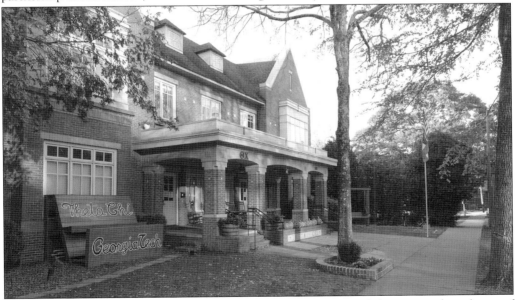

THETA CHI FRATERNITY, 2000–2003. While Randy Zaic remained the principal in charge of design at Zaic/Hug, this was Michael Hug's project. Hug often worked out the plan and, in this case, collaborated with Greg Laden of the firm, who developed the exterior with its Craftsman detailing on the porch and interior and its traditional brick construction. The house replaced a late 1952 fraternity house. (RMC.)

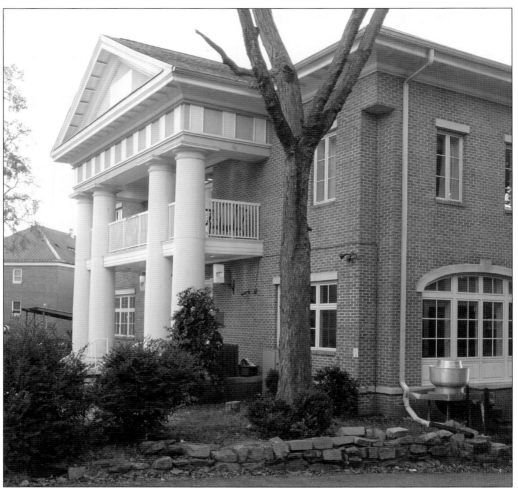

LAMBDA CHI ALPHA FRATERNITY, 2005. The evolving life of the Lambda house began with a c. 1957 design by campus architect David Savini. Subsequently, John Harte's distinctive use in 1966 of decorative pierced concrete blocks, popular in the late 1950s and after, was transformed to a broad, four-bay, three-story screen forming the entire west elevation of the present building. The 2005 work of Richard Whittshiebe Hand was part of a "complete retrofit" of the fraternity house—in the words of the architects, "stripped down to the structure and transformed from a 1960s vintage contemporary design to a Georgian mansion." Rejecting the idea of a complete razing of the existing house, Hand preserved in the fabric of the new a part of the local chapter's architectural history. (RMC.)

SIGMA CHI FRATERNITY, 1995. Sited on a prominent corner lot, Sigma Chi fraternity house features a restrained neoclassical rotunda, with an open Roman Doric colonnade forming a porch. The stripped building surface above and behind exhibits cookie-cutter fenestration, blank brick panels, and an awkward roof edge in want of a more substantive cornice and overhang. Architect Hand is a chapter alumnus of Sigma Chi. (RMC.)

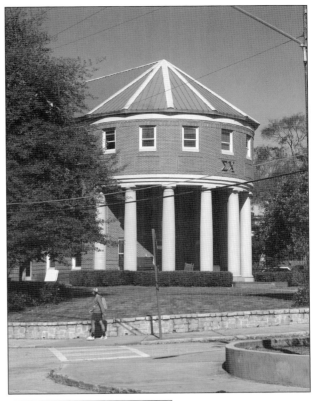

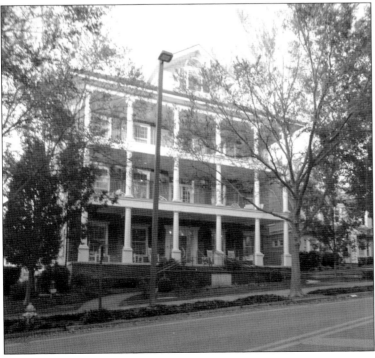

ALPHA GAMMA DELTA SORORITY, 2011–2012. For several years on this site, the sorority occupied (and subsequently enlarged) the 1938 studio residence of sculptor Julian Hoke Harris. With increases in membership, the house was outgrown and razed. Stevens and Wilkinson designed the current four-story-plus-basement sorority house with its prominent three levels of full-width porches, providing a "southern" verandah character times three. (RMC.)

DISCOVER THOUSANDS OF LOCAL HISTORY BOOKS FEATURING MILLIONS OF VINTAGE IMAGES

Arcadia Publishing, the leading local history publisher in the United States, is committed to making history accessible and meaningful through publishing books that celebrate and preserve the heritage of America's people and places.

Find more books like this at
www.arcadiapublishing.com

Search for your hometown history, your old stomping grounds, and even your favorite sports team.

Consistent with our mission to preserve history on a local level, this book was printed in South Carolina on American-made paper and manufactured entirely in the United States. Products carrying the accredited Forest Stewardship Council (FSC) label are printed on 100 percent FSC-certified paper.